T0303785

SECRET
TRURO

Christine Parnell and Sheila Richardson

AMBERLEY

Dedicated to my dear brother Bing (who lost his fight to Covid in January 2021). 'A proper Trurra Boy'
Sheila

For all my lovely family.
Christine

First published 2022

Amberley Publishing
The Hill, Stroud
Gloucestershire, GL5 4EP

www.amberley-books.com

Copyright © Christine Parnell and Sheila Richardson, 2022

The right of Christine Parnell and Sheila Richardson to be identified as the Authors of this work has been asserted in accordance with the Copyrights, Designs and Patents Act 1988.

ISBN 978 1 4456 9936 3 (print)
ISBN 978 1 4456 9937 0 (ebook)

All rights reserved. No part of this book may be reprinted or reproduced or utilised in any form or by any electronic, mechanical or other means, now known or hereafter invented, including photocopying and recording, or in any information storage or retrieval system, without the permission in writing from the Publishers.

British Library Cataloguing in Publication Data.
A catalogue record for this book is available from the British Library.

Typesetting by SJmagic DESIGN SERVICES, India.
Printed in Great Britain.

Contents

Introduction 4

1. About Town 8

2. Rivers, Bridges and Waterways 16

3. Townspeople 24

4. All in A Day's Work 30

5. Calling for Help 38

6. Places of Worship 47

7. That's Entertainment! 58

8. Eat, Drink and Be Merry 68

9. Beyond the Boundary 75

10. Ghouls and Ghosts 84

11. The Cross Restored 92

Bibliography 95

Acknowledgements 96

Introduction

Truro is an unusual name for a town, and theories surrounding its origin have changed over time. It was once believed to be derived from the translation of 'three roads' from the old Cornish language, alluding to the main roads that lead in and out of the town: Pydar Street, St Clement Street and Kenwyn Street, Kenwyn Street causing some confusion as various streets had that name at different times.

These days, it's widely accepted that the meaning actually comes from the three main rivers: the Kenwyn, the Allen and the Glasteinan, otherwise known as the Tinney River. The Kenwyn used to glory under the name *Dowr Ithy*, which translates to 'the fragrant river', though fragrant doesn't give the right impression.

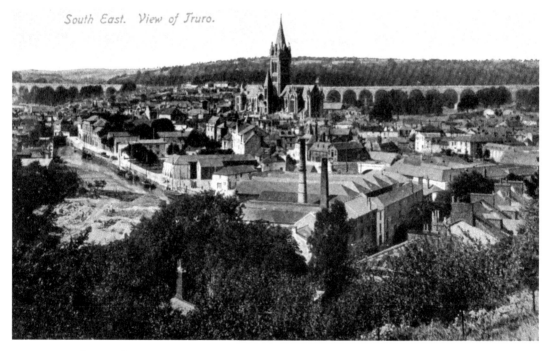

A view of Truro showing the cathedral's central tower, completed in 1905 and named after Queen Victoria. Ships are moored on the River Kenwyn at Back Quay (*left*), showing how important the waterways were for the trade of the city.

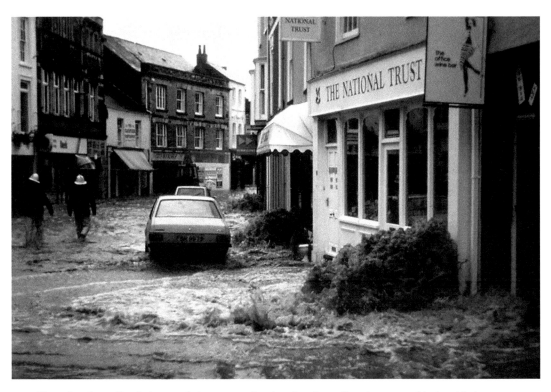

Truro has been flooded several times over the decades; in earlier times, an old air-raid siren was used to alert residents. This photo shows the River Kenwyn flowing through River Street.

The merging point of the rivers formed the Truro River, then an important highway for travellers, and quays and boatbuilders lay up and down the riverbanks. The land around the area proved to be good farmland, and by the middle of the thirteenth century the Dominicans, more commonly referred to as Black Friars, had come to Truro to build their friary and establish their wayside preaching cross. Considered then to be an up-and-coming town, permission to build the first charter was granted by Richard de Lucy in 1153, and the town prospered.

Over the years, the fortunes of the new settlement fluctuated. Between the early to mid-seventeenth century, mine owners – such as the Great Mr Lemon and Thomas Daniell – built magnificent houses as the product of their wealth. Much of Truro's financial stability depended on the mining of tin and copper, and residents would regularly raise a glass to 'copper tin fish'. It wasn't just the lifestyle of the adventurers or mine owners that depended on this financial prosperity, but also the lowly souls that worked for them.

Upon being granted city status in 1877, plans were then drawn up for the building of the cathedral, which rises gracefully at the centre of the town. Part of the old St Mary's church, the south aisle, was retained as the local parish for those who lived nearby, but while the cathedral was being built, a large wooden hut sufficed for worship.

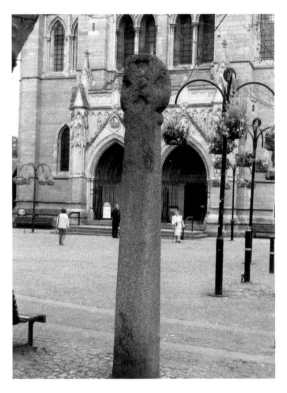

Left: The medieval wayside cross, prior to the accident that destroyed it in February 2019.

Below: Aerial view from the balcony of Victoria Tower showing the two western spires, Edward and Alexandra.

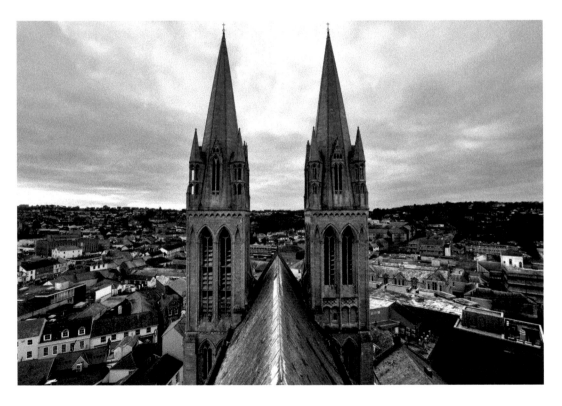

In 2019, a reckless driving incident resulted in damage to the ancient high cross that stood outside the cathedral, invoking a sadness within many of the locals. After spending many years lost, it had only been restored to the historic site in 1988 after being found under a road in the 1950s. It now sits in pieces awaiting repair.

Many of the residents have lived and worked in Truro for most of their lives. Like many towns, the buildings and streets have changed over time, but the heart of Truro remains unique.

Filled with rich history and lost historic buildings – including an adulterine castle, the Dominican Friary and, being a stannary town, various lost public houses – it's not surprising that there are many secrets that surround the city.

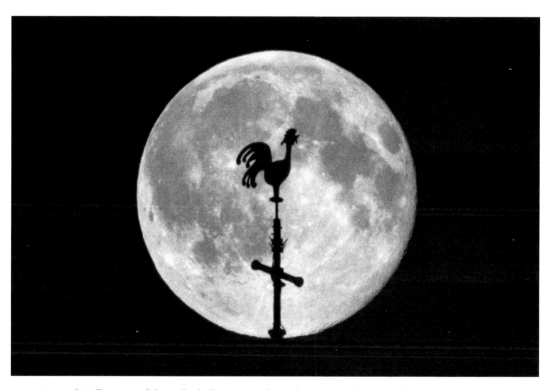

A moonlit silhouette of the cathedral's cross and weathervane, sitting atop the central spire.

1. About Town

The streets of Truro today, filled with shops and traffic, would not be recognised by the residents hundreds of years ago. While many of the buildings are the same, the character of the city and the lives of the people have drastically changed.

Up until 1794, there had been narrow streets and cobbled lanes, not suitable for much more than the passing of packhorses and mules, which were often bearing blocks of tin and copper from the mines. In contrast, Boscawen Street is now a spacious thoroughfare due to the loss of Middle Row, once the main street of Truro.

It was also around this time that the Paving and Lighting Act was passed, revolutionising the appearance of the town and enabling the council to dismantle Middle Row – all of it but the Market House, which continued to house the council chamber and stand as the business of the borough for another twenty years after the demolition. This was mainly due to funds being in short supply.

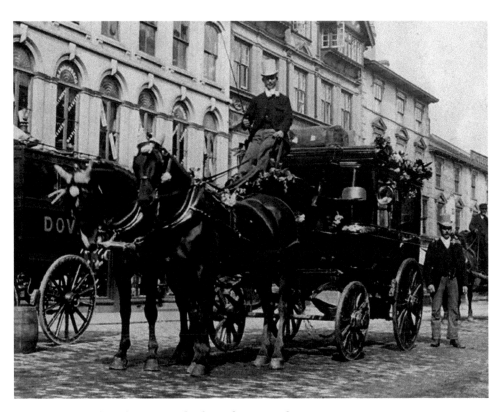

A grand horse and coach wait outside The Red Lion Hotel in Boscawen Street.

In 1790, with plans for a new Market House postponed, the initial decision was made to alter the current property, and in 1821 the council resolved to pull down all of the houses that stood in front of the building, all of which were purchased by the corporation for the purpose of extension and renovation. However, they eventually settled on building a new premises, and in 1846 Dr Clement Carlyon laid the foundation stone of the new Municipal Building. He justified this decision with a speech detailing how the central row of houses were of a run-down, inferior description, and emphasised of the old Market House that

> our worthy predecessors met for all municipal purposes in there prior to the erection of the present Assembly Room, not only election balls, but all public dances and concerts took place. This was the only theatre in which exhibitors of various kinds and lecturers could be accommodated.

Prior to the demolition of Middle Row, the streets either side of it were called Market Street and Fore Street, but sources have also been found where they're referred to as Powder Street and Coinage Hall Street.

The areas are full of small pathways called opes, which enabled people to take shortcuts from one street to another. Middle Row had one called the Opetjew, the origin of which stems from the Cornish '*dhu*', indicating that it was dark and probably dirty. Over the years, many opes have been lost and closed off, like King Street, Burton's Ope and Cathedral Lane, but others, such as Pearson's Ope and Roberts Ope, still remain and are used to this day to navigate the busy city. The narrowest of these passageways is Squeeze Guts Alley.

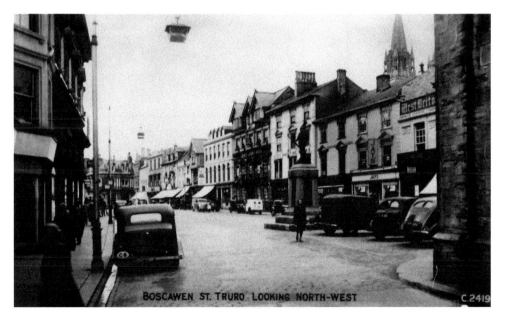

Boscawen Street *c.* 1950s, displaying the vehicles and fashions of the era. The *West Briton* office and Jay's Furniture store sits on the right.

Carne's Ope, while remembered by many of Truro's older residents, has been closed for many years. This ran from Boscawen Street and emerged by The Market Inn on Back Quay – many people remember it as Millican's Ope or Lampier's Ope, from the shops that were once there. With thanks to Bert Biscoe and colleagues from Cornwall Council, a recent survey was conducted with hopes of reopening this once frequently used shortcut. Once home to Carne's brewery and a large family – Mrs Pearce and her eleven children – it's considered to be a hub of much historical activity.

Boscawen Street was the location of one of the properties known in Truro as The Great House, the home of the Roberts family, who later changed their name to Robartes. The house sat on the site of today's HSBC and was the first house to be built on the north side of the street. On the west side of the house were Tudor windows with granite mullions, and it had a grand garden facing King Street. On the same street, another stately home sat on what is now The Red Lion. While the plaque on the door was dated 1671, it was later discovered that the building actually dated back to Tudor times. It's believed the residents, the Foote family, decided to modernise their home with a new front to the old building which now proudly proclaimed the new date 1671 over the door. Samuel Foote, the owner of the house, was a well-known local actor and dramatist. He was born across the road in the home of Johnson Vivian, which stood on the site of a property once

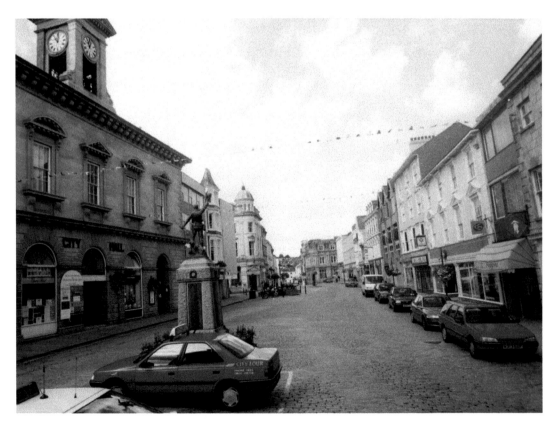

A view of Boscawen Street, showing the City Hall (*left*) at a time of festivity.

Aerial view of Truro's historic clock tower.

known as Anhell. This had been a convent and housed a community of nuns known as Poor Clares.

Several streets around the town have plenty of stories to tell, and Campfield Hill is one of them. The garrison town for the Cornish Royalists in the Civil War, Truro was the headquarters of Sir Ralph Hopton and Sir Richard Grenville. At only fifteen years old, Prince Charles (who later became Charles ll of England) was appointed commander of the Western Army and came to Truro, where he stayed at Lambessow. Cornwall lost interest in the war after their Cornish gentry were slain – they had lost Grenville, Godolphin, Trevanion and Slanning. It was only Sir John Arundell, who defended Pendennis Castle, who held out for another six months after the surrender of Hopton to Fairfax on Tresillian bridge; nine brigades of the Royalist Army gave up their arms to Fairfax when he entered the town and Royalist camp. To this day, many believe that this camp is honoured in the form of Campfield Hill, but Henry Leslie Douch, who was the curator of the Royal Cornwall Museum for many years, argued that the name was much older. He suggests that it's derived from the French '*champ*', meaning field.

There's a theory that Coombes Lane was originally called Combers Lane, and that it provided housing for those who lived and worked in the old wool factory. However, at the beginning of the eighteenth century, a building owned by a man called Mr Eades stood there, and part of it was occupied by the bakehouse of Mr Coombe, so the origin of the name remains uncertain.

Photograph of Campfield Hill and Truro Vean Terrace, featuring many surrounding rows of cottages.

Coombes Lane, one of Truro's narrow opeways, providing a shortcut from Pydar Street to The Leats. There was once a dame school here, which provided education for Richard Lander.

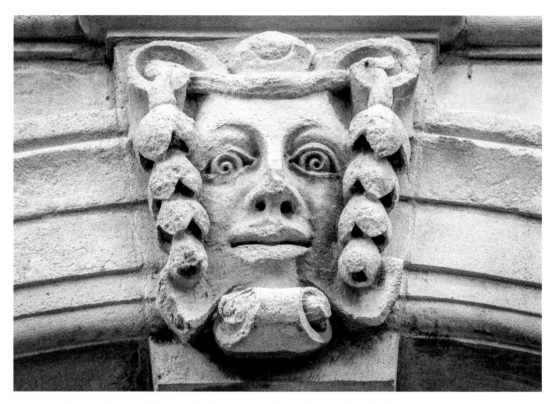

One of several ornate plaques adorning the old Burton building in King Street.

Part way up Chapel Hill is Parkvedras Terrace, a street that is believed to have been the site of a previous leper colony, as excavations revealed old walls that supposedly suggested the formations of such a house. The location would have made it a good place for sufferers to ask for alms from travellers going in and out of the town.

Further on, situated on what would have been part of the friary land is St Dominic's Street, the name of which commemorates the Black Friars who settled in Truro in the mid-thirteenth century. Once known as Back Street, St Mary's Street is now affectionately deemed the draughtiest street in Truro.

St Nicholas Street is named after a group of traders who formed a guild known as the Fraternity of St Nicholas and owned properties in the street *c.* 1278. Originally this road was believed to run from the area of the West Bridge to the quay.

An ancient passageway, Tippetts Backlet is another well-known street, although the direction it leads has been altered in recent years. It now runs from River Street to The Leats, but it once stood at the back of what was then Nankivel's Brewery and was home to an octagonal building known as The Cockpit, a place frequented by fashionable country gentlemen who made Truro their winter resort. Presumably less prestigious customers used it as well, although nowadays cockfighting is considered a cruel sport, and it was pulled down in 1889.

Legend has it that King Arthur and his knights fought a battle on the 'Strand of Truro'. It's thought that this formed part of Lemon Quay, formerly known as Market Strand.

After the cockpit was demolished in 1889, a chapel was built on the site. The congregation was derogatively know as the 'cockpitarians'.

Another unusual street name was Neptune Row. Situated by the Mill Pool, by 1823 the row consisted of only four cottages, but over the years more properties have been added. Solar Row and Lunar Row flank the public house known as The Rising Sun in Mitchell Hill. It seems that the builders, looking for names for their new properties, were gazing at the stars for inspiration.

DID YOU KNOW THAT?

The granite flower bed in the middle of Boscawen Street is actually the town's horse trough.

The cattle market was situated close to the town, where the Crown Court building is now. On Wednesdays, which was market day, children often crept into the market to playfully walk across planks of wood that had been placed across the sheep pens for the auctioneer to stand on. While they weren't allowed to do this, dodging the brown-coated officials made for an enjoyable pastime. There used to be a railway halt that proved useful for unloading and loading cattle, but this has long gone.

Close to the old cattle market was an area known as The Splatt, where cattle lorries parked to be washed off and then to reload new stock bought at the market. In days gone by, the market site was home to Truro's adulterine castle, but now there sits The Crown Court, while police cars park on The Splatt.

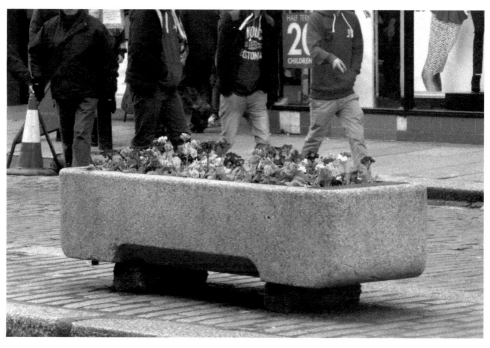

This granite trough, once used for watering the horses, has found new use as a pretty flower bed in Boscawen Street.

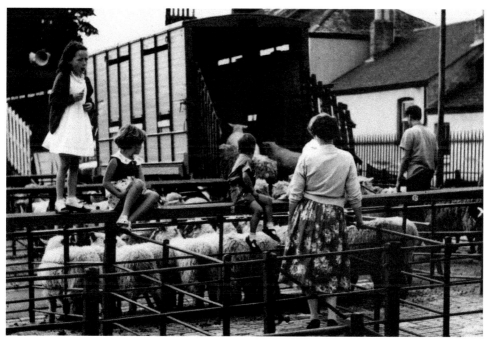

Wooden planks were placed between the pens at the old cattle market, where children used to climb. The new market was transferred to the eastern side of the city.

2. Rivers, Bridges and Waterways

Truro's position at the head of a large estuary, and the various rivers, quays and waterways that feed into it, have played a vital part in the history of its development. Since 1877, with the proud status of being Cornwall's only city, the rivers still play an important role in the popularity of the area.

However, historically it was not always beneficial for the town to be accessible by sea, as in the mid-fourteenth century pirates from the coast of Africa would sail up the river and ransack the town. In 1557, France and Spain were so engrossed in their battle with each other that they did not seem to notice the fact that they had come up the river as far as Malpas.

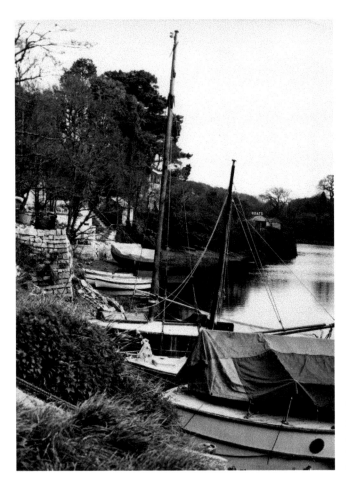

The entire stretch of the riverbank at Sunny Corner and Malpas was often dotted with numerous boatbuilding enterprises.

DID YOU KNOW THAT?

Malpas elects its own mayor every year. This is not a political position, but for someone from the village to have the privilege of attending fêtes, competitions and other community events. One of the highlights of the year is the awards ceremony after the regatta. It's customary for the new mayor to turn up in the regalia of a toilet chain, complete with handle, and various other bits and pieces that have been attached by other mayors over the years.

Overlooked by the little church at Malpas was one of the many boatyards that dotted the riverbank, that of Scoble and Davies. They built the largest boat in Malpas and launched her in 1872. Called the Malpas Belle, she rounded Cape Horn and escaped near destruction by a submarine in 1916. This survival was short-lived, as four years later she was eventually found wrecked along the Devon coast at Seaton Head.

A few years ago, the secretary of Truro Old Cornwall Society received a letter from an elderly Irish gentleman. He had been a navvy during the Second World War and spent time in Truro digging in the area of Malpas park. With no idea for what reason he was digging, just being told it was war work, he asked if anyone could disclose what he'd been doing and whether it had really helped the war effort. The secretary was able to tell him that he'd most certainly done his part, as he'd been digging a slipway for the purpose of launching some Mulberry harbours that were built on the Truro River and used on D-Day. They were named by Lord Falmouth while sitting in his garden, where his committee asked what they should call the docks, only for him to gaze up and realise that he was sitting under a mulberry tree.

The Kenwyn and Allen rivers were used to power the mills that were dotted all along them. The town mill, a grist mill, was situated where the end of River Street meets Victoria Square today, and the pit for the large waterwheel is still visible at the back of the property. The best-known mill is likely the Manorial Mill, built on the River Allen, which flowed down to the back of St Mary's Church. Today, with its respectively quiet waters, it's known as the mill pool and is most often seen in the famous photographs of circus elephants bathing in its waters over a hundred years ago.

Leading on from here, the river ran through sluice gates into the dye works of the carpet factory. Although they definitely didn't add to the cleanliness of the water, these works provided employment for hundreds of people.

In later years, a swimming pool was built just below the Old Bridge in the old Women's Institute meeting room, using water drawn straight from the river. Meetings and dances were held in the room, while the pool was covered by planks. Naturally, there were concerns about the safety of this set-up, especially during a lively dance. The other swimming pool was situated at Sunny Corner where, depending on the tide, a few tiles can still be seen that once formed the bottom of the old pool. However, it was really more of a lido, formed from part of the river regularly used by the swimming club and

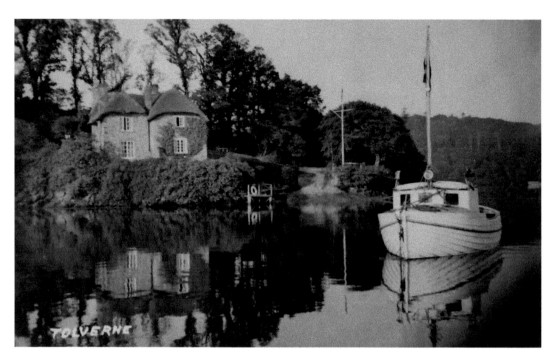

During the Second World War, the peaceful Smugglers Cottage at Tolverne was a hive of much activity. American troops used this area to prepare before the D-Day landings.

A modern walkway at Malpas park. It was here that a slipway was built to launch the Mulberry harbours during Second World War.

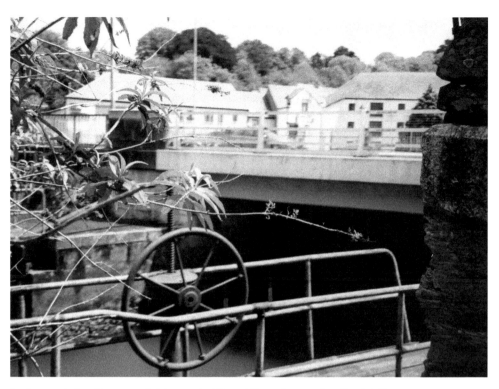

Lock gates below Boscawen Bridge on the River Allen, often used as flood defences.

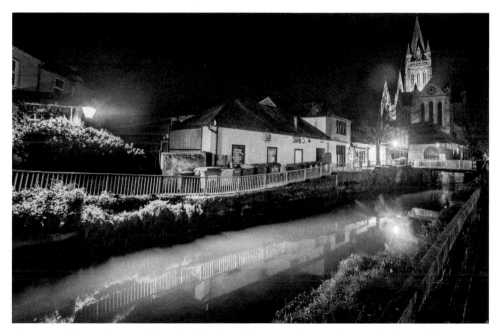

The River Allen. In bygone days, the dye from the carpet factory frequently altered the colour of the river.

local boys. Sunny Corner has always been a regular place for local boat owners to moor and tend their boats.

During the war, a River Patrol was formed to guard the waterway into Truro and, until his death, Cornish historian Professor Charles Thomas was compiling a history of the men who volunteered for this service. For many years, timber was set on the river to float until seasoned. Along the riverside path, at Malpas Road, humps in the grass known as timber humps are all that remain of this tradition, their purpose now solely to entertain children visiting the park.

Truro's third river, the little Tinney, was mentioned in the *West Briton* in June 1967. Referred to as the forgotten river, it had disappeared at the beginning of the eighteenth century due to various developments. However, a trickle of the river was discovered in Tregolls Road, where the police station stood at the time. The stream was at the junction of two tributaries, one from Tremorvah and one from Vineyard Farm. The water reappeared from an old stone culvert, but the curator of the museum, Henry Leslie Douch, said that it was likely to disappear again when the new ring road was built. This little river, which used to run downstream and pass under Staddon Bridge, has been referenced as far back as the thirteenth century.

The River Allen, though flowing calmly through The Leats in this photograph, has been known to flood many neighbouring homes.

At that time, the dues charged by the Truro Corporation for cargoes brought up to Lemon Quay were costly, resulting in two merchants, Jeremiah Runnalls and Samuel Pascoe, erecting stores on the St Clement side of the river. A bank was made on the mud and a private landing place constructed, serving to bypass any dues payable to the Corporation. Subsequently, other quays, wharves and warehouses were built on the same side.

Until the beginning of the nineteenth century, there was a ford across the River Allen but no bridge, but the need for one must have been urgent. These were the days where only coaches, horse wagons and manpower could be relied on to pull heavy mine machinery, and they all had to use the narrow Coinage Hall Street and New Bridge Street. The first bridge, a superstructure of wood resting on stone pillars, was opened in 1849. In 1850, it was decided that this bridge, known as Donkey Bridge, was unsafe and was promptly closed. A local Truronian, Henry W. Farley, designed the next Boscawen Bridge, which opened in 1862 and only closed upon the advent of the ring road in 1967.

Various shipments have been carried up and down these rivers, but Truronian Grenville Penhaligon relates an especially amusing story from when he was a boy. Living in a house near New Bridge Street, he fondly remembers his grandfather travelling up the river in a rowing boat carrying an unusual cargo: a donkey. Nobody knows how the donkey managed to get in and out of the boat, but he does recall that it was kept in the cellar for some time. Every time the tide came in, it had to be moved to a higher room.

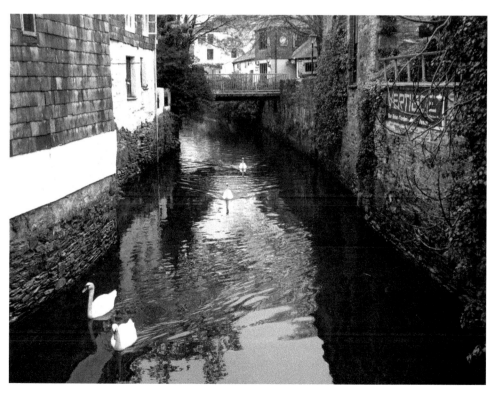

The River Allen from the perspective of Old Bridge. On the right sits the premises of the former WI building, where one of the rooms contained a swimming pool using water from the river.

A pastime enjoyed by many local children was something known as 'walking the pipes'. Beginning at the end of Daubuz Moor near the steam laundry, sewage pipes fed under the road bridge at Moresk and finished at the mill pool behind the cathedral. At the bottom of Boscawen Row, a few stone steps enabled children to clamber onto these large pipes that were centrally positioned on the river and walk across them. Throughout the school holidays, it was a child's delight to carefully balance as they proudly travelled up and down the river, arms outstretched like a circus trapeze act. It was quite common for youngsters to fall in the water and spend endless hours beating their socks against the railings or hanging them up to dry before they dared to return home. Occasionally, the steam laundry opened the lock gates, causing the river to swell. A torrent of water would rush downstream, washing away everything in its path. Despite this, the Daubuz Moors, through which the River Allen flows, was a haven for children to play and have picnics. They'd often be armed with a glass jar and string, fishing for minnows and other small fish, setting them free before returning home.

Another unusual feature of Truro is the leat system, which is channelled through the town. In summer, the sparkling water runs alongside the pavements, and it is not unusual to see dogs pulling on their leads to paddle in the gutter.

In the days before traffic and accessible motor vehicles, very few Truronians could afford a car, so it was common for affluent visitors to park in Boscawen Street and explore the city. In most cases the visitor would step straight into the water and get a soggy shoe.

Although Truro Water Company no longer exists, a few old manhole covers still survive.

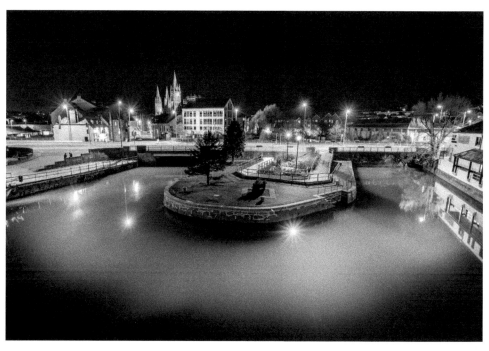

The street lights illuminate high tide at Worth's Quay. Behind the quay, the box-shaped building is Haven House, which used to be home to Penrose Sailmakers, once makers of the largest sail in the world.

The Victorian leat system in Pydar Street, once responsible for washing the gutters of the town.

3. Townspeople

Truro is a lovely, friendly city. However, like most places, it has lost countless family-run shops and independent businesses, many of which the locals once depended on. While many familiar characters of the city have also been lost, some of them stand out for their own special reasons.

Dr Margaret Pollard, known as Peggy Pollard, was a popular presence in Truro fifty-or-so years ago. Born Margaret Steuart Gladstone, she was the great-great-niece of William Gladstone, a statesman and politician who served as one of Queen Victoria's Prime Ministers for twelve years. As an elderly lady, nobody would have guessed that she had been a gang leader. In 1927, intelligent and Cambridge-educated, Peggy and a group of friends founded Ferguson's Gang and gave themselves pseudonyms: Bill Stickers (Peggy), Bludy Beershop and Red Biddy. Their purpose was to deplore the ruination of much of the country's landscape and traditional architecture, and all of their efforts were geared to anonymously raising money for the National Trust.

Peggy was married to Frank Pollard, who wrote for an undergraduate paper at the university and operated under the pseudonym Uncle Gregory. When they lived in Truro, he was known to all as Captain Pollard. An ex-naval man, sailing was his passion, and in the 1960s he purchased a rowing boat for the Truro Sea Cadets.

Very knowledgeable about local history, he appeared on quiz programmes for both the BBC and ITV, in teams comprised of Donald Vage the jeweller and Christine Mitchell, a Truronian County Grammar School student. After the quiz series ended, Peggy always treated the team to an evening meal in The Red Lion, although she never chose to attend herself.

Another Truro character was Miss Ena Coombe, County Commissioner of the Girl Guides and one-time mayor. Known as Skipper to the small group of sea rangers, she once asked Captain Pollard if her girls could have use of the sea cadets' boat. Upon his approval, the girls spent many hours rowing up and down a small part of the river at Malpas. In a time of lax health and safety regulations, no one had life jackets, and it's likely that none of the crew could swim. There was an unfortunate incident where Miss Coombe was demonstrating how to walk along a plank and climb into the boat, but as she was ceremoniously boarding, she slipped and fell in the mud.

A historic and loved figure of Truro was Mrs Jacobs, who lived in the city for the best part of eighty-five years. Between the 1950s and 60s, after raising her large family, she was a familiar sight on weekday afternoons, where she stood by the Gas Showrooms in Boscawen Street and sold copies of the *West Briton* and *Evening Herald*. In her older age, she continued to sell the papers from her house at Trelander, often with a large gathering of neighbours who enjoyed visiting, amused by her humour and good nature.

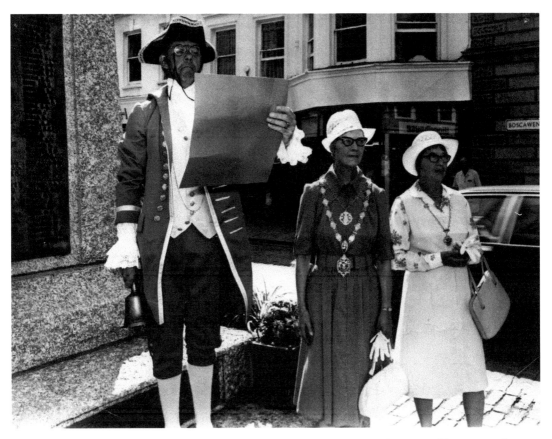

The Town Crier proclaims the day's events. Miss Ena Coombe, Mayor of Truro, and her sister, who was her escort, stand proudly by.

In 1979, when Truro Twinning Association was created, they held a competition at Boscawen Park for a town crier, hoping the elected candidate would declare the forthcoming events of the Twinning Association. Adorned with lace and frills galore, suited up in a home-made outfit, Mrs Jacobs outshouted her male opponents and was duly awarded the position. This was apparently the first time in decades that the town crier's handbell had seen the light of day, having been stored away in the clock tower.

Mrs Jacobs and her friend Mrs Goddard were regular participants in the revived Truro Carnival for twenty-one years, up until 1993 when the carnival was temporarily discontinued. Each year, with new topical captions, they delighted the applauding crowds of Truronians as they walked the carnival route. On the last year of their entering, their caption was 'Twenty-one Birthday Wishes, *Re-lion* Us We Never Misses', and the spelling was a nod to the Lions Club who did significant charity work. Mrs Jacobs died in 1994.

One of the fine townhouses in Princes Street has been home to a variety of notable gentry, such as the Gregor family, Lord de Dunstanville and Henry Rosewarne, to name

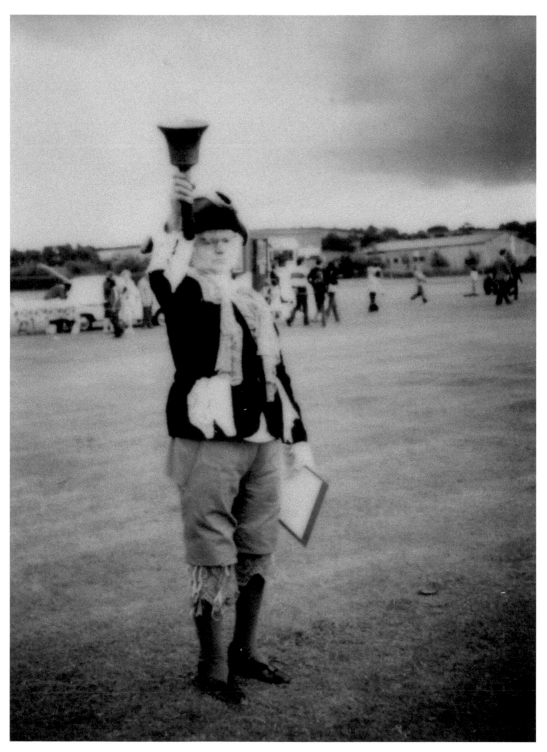

Mrs Georgina Jacobs, newly appointed crier for the Truro Twinning Association, performs her duties at Boscawen park.

just a few. For many years, it also functioned as the shop and printing works of Oscar Blackford Ltd, which during the 1950s and into the 1970s was managed by Mr Stanley Sunley, the city councillor and brother of Mr Bernard Sunley, a celebrated British property developer. Despite being an outstanding character and respected employer, his staff mostly remember him for his outrageous temper. In 1961–2, he stood as Mayor of Truro.

The donation to build Truro's Bernard Sunley Gymnasium came from his brother, Mr Bernard Sunley, and it was opened by the Sunleys' good friend Mr Frankie Vaughan, who was also a supporter of the Boys' Club. Bernard annually visited Stanley at his work, and on one occasion he required a haircut. He stubbornly refused to go to the barber and insisted that the barber must come to him. Mr Thomas, barber of Victoria Square, was consulted. At first he flatly refused, explaining that he was unable to close his shop on account of one customer, but after much persuasion and payment of a sum of money that he could not refuse or disclose (it still remains a secret), he obliged.

The camaraderie and friendship of the ladies who worked at Blackfords over fifty years ago continues to the present day, with some of them still maintaining regular contact.

Miss Ada Alvey taught Geography and handwriting lessons at the local grammar school, and also ran a group of Cub Scouts. After she retired, she was often found enjoying a hot drink in the cathedral refectory, full of stories to tell.

In 1939, before the outbreak of the Second World War, Ada and her sister went on a cycling holiday. They were in Germany when one evening, not knowing that there was a curfew, she went out to get some stamps so she could send some postcards home. She was tapped on the shoulder and turned to see a handsome young German officer who asked what she was doing and asked her to follow him. After taking her to a local castle and supplying her with the stamps she required, he escorted her back to her lodgings and warned her not to go out after the curfew again. After this incident, the sisters decided to return home, and it was some time after the war had started that Ada saw a picture of the castle in a newspaper: Spandau. By the end of the war, she realised that it was the same castle that many people had never come out of – alive – again.

Foster Gill was a very short little man who wore a cap and smoked cigarettes. He lived with his elderly father in Fairmantle Street and was a friendly and familiar sight in the town, often recognised for the squeaky noises he could make with his lips, much to the amusement of local children. Throughout the 1960s, he sold newspapers on the corner of Lloyds Bank. Sadly, Foster was tragically killed in a fairground accident in Truro in 1968.

Another of Truro's much-loved and respected characters was Clarice Mortensen Fowler, a spritely nonagenarian, renowned not only for her youthful and glamorous good looks but also for the huge amount of money she raised for various charities. Splendidly dressed in Cornish tartan from head to foot, Clarice was often to be seen leading a parade or carnival through the streets of Truro. At her home in Rosewin Row, she often baked pasties, carefully wrapped them in layers of greaseproof paper tied with ribbon and donated them as gifts or prizes to local organisations. In recognition of her public service, she was made an Honorary Citizen of Truro.

Ashley Rowe first comes to note in the minute book for the Truro Old Cornwall Society, when he was elected vice president in 1935. The following year, he became the

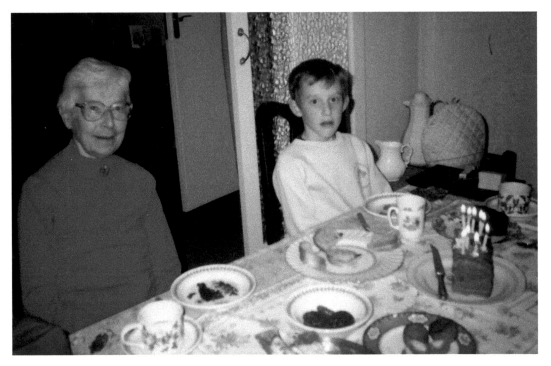

A young Cub Scout enjoying tea with Miss Ada Alvey.

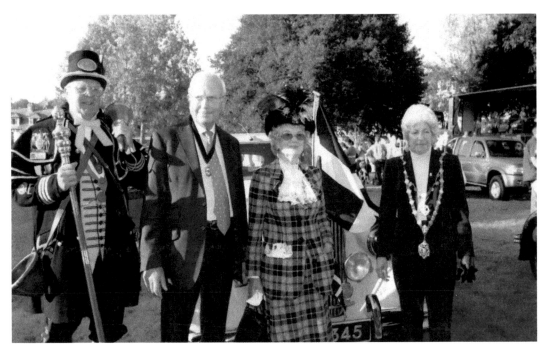

September 2008: Clarice Mortensen Fowler, looking splendid in her Cornish tartan outfit. She often led the Truro Carnival procession. Pictured with her is Mr Sweetman, the Town Crier.

recorder, a post he held until 1958. The recorder is responsible for compiling any items of history, anecdotes, photographs, etc., and looking after them for posterity. Mr Rowe was exceptional in this role: he was a marvellous historian and regularly wrote for the *West Briton.*

DID YOU KNOW THAT?

If you work or live in the Lemon Street area, you will no doubt have been acquainted with Mr Jingles. This tabby feline with a distinctive white bib and paws frequents shops, offices, hairdressers and even the cinema – anywhere he can find food and affection. He is a lovable cat that proudly roams the streets by day, pretending to be of no fixed abode but finds his way home to Carclew Street at night. He is often to be found waiting for his favourite Italian restaurant to open before moving a few doors up to his special seat in the foyer of the Plaza Cinema. Sadly, Mr Jingles has now passed away, but a local solicitor had been regularly providing him with food, bed and veterinary care.

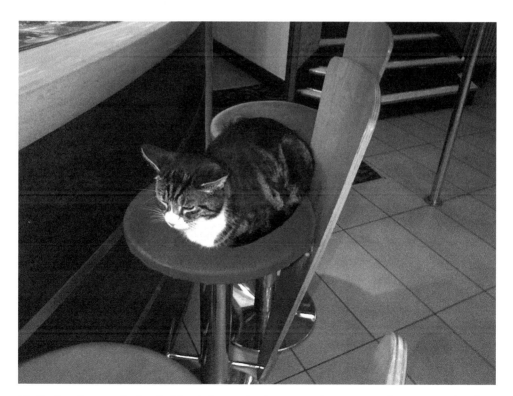

Mr Jingles, the cat who has befriended many in the Lemon Street area, takes a rest at the Plaza Cinema.

4. All in A Day's Work

The tale of the lion and the barber is one that many elderly Truronians might know, but it's unlikely to be known by many of the locals today. Bernie Peters wrote about his father Eddy and grandfather Jacko who were barbers in Bridge House, New Bridge Street. His grandfather used a cut-throat razor and was a very quick shaver and had several times won the West of England Hairdressers Championships. The shop was often full of waiting customers, although some just wanted to speak to Eddy, who studied horse racing form and often shared tips. One morning, when Wombwell's Circus and Menagerie was in town, Jacko was talking to a new customer about the circus' lion tamer. He was of the opinion that the lions were likely not that much of a threat: bred in captivity, they were elderly and probably toothless. The customer wondered if he'd be prepared to place a £5 bet, where Jacko would shave a man while sitting in the cage with the lions. Not realising that the stranger was the lion tamer himself – Mr Courts – and knowing that at the time that £5 was a lot of money, he confidently agreed. Secretly, he was afraid of what he was letting himself in for, but he still showed up at the circus ground at eight o'clock the following evening. Wombwell had seized the marketing opportunity and paid a young lad to distribute some flyers around the town, so a large crowd had gathered to witness the event. Jacko Peters did actually shave a customer in the presence of the lions; it was the fastest he'd ever shaved a man in his life.

Bernie remembers his granddad was always reluctant to increase the cost of haircuts. Instead, he had arrangements with certain customers whereby it was acceptable for them to pay with eggs, mackerel and pheasant – or even a basket of Kea plums.

In 1958, the obituary of William James Moyle described him as an 'exponent of the ancient craft of brush making'. Coming to Truro in 1918, he was the owner and manager of the West of England Brush Factory. The business was situated in Tabernacle Street, and one of the company's General Registers of Employment dating from 1911 reveals that many of the boys and girls employed there were around the ages of fourteen and fifteen. Signatures from both parents and a certified surgeon were required to testify their fitness levels and deem them suitable to work in the factory, which made and repaired all manner of brushes and brooms, some for domestic use, but mostly for use on farms, mines and other commercial businesses. When William Moyle died, the ownership and management passed to his son Harold, by which time the brush-making business was over one hundred years old. When the business closed in Tabernacle Street, Harold continued to repair and supply from his own home.

Most of his work was handmade with bristles, twine, bitumen and an exclusive inside knowledge. He was reputed to have been the only person skilled in this craft in the west of England, and the sole supplier in the country. On his death, the business ceased completely, causing many companies to close.

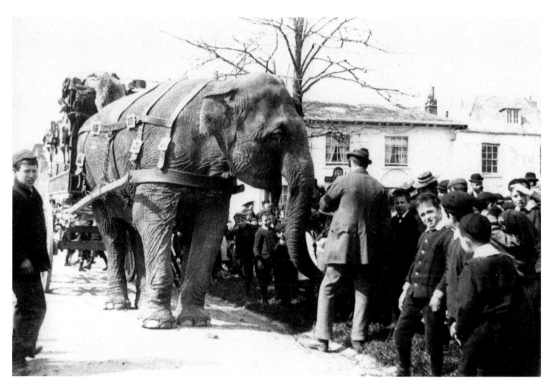

Wombwell's Circus and Menagerie.

During the 1970s, the telephone operators of Truro Exchange received a few more calls than usual: subscriber trunk dialling, without the assistance from switchboard operators, had now become available in Truro and certain neighbouring areas. Telephone numbers that were originally four digits were now six, enabling people to directly dial numbers themselves without intervention from the switchboard operator. However, this led to some confusion, and one elderly gentleman from Camborne who had been used to calling the old way was having difficulty getting through. The operator kindly explained over and over again that he now needed to prefix the number with two more digits, but he persisted, 'I've tried dialling what you've told me, but I still can't do it cos I've dialled the 2 but there's only one 'ought [nought] on the dial!'

Another caller using a kiosk telephone was complaining bitterly of losing her money in the box. The operator needed to differentiate whether the kiosk was a renter's box or whether it was a GPO public call box: 'Is it a street call box you're calling from?' she asked the caller. At this the caller gave an indignant reply: 'No, of course it's not, it's on the pavement!'

Retried today, Grenville Penhaligon had a variety of occupations, but he spent most of his life working as a cinema projectionist, taking care of the huge carbon-burning projectors and waiting for the dots to appear in the top right-hand corner of the screen, his cue to change the reels.

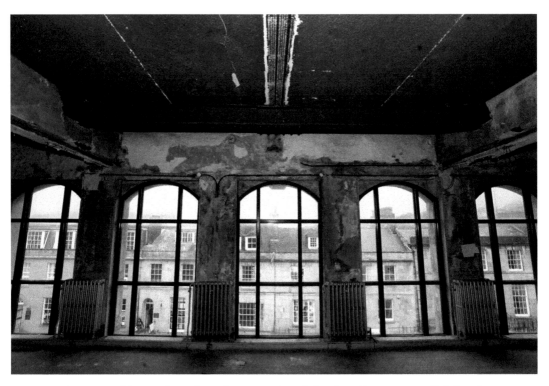

An unique view of Lemon Street from the perspective of the Plaza Cinema, once a lighting shop.

Previously a lighting shop, many of the older residents of Truro can recall the upper storey of the Plaza having a life of its own, adorned with beautiful lampshades and sparkling chandeliers. Mr Penhaligon states that it was rented by a company called Metropolitan Distribution, who also sold washing machines and hi-fi equipment. In those days, it was possible to request to see the washing machine that you wanted to buy in action, and if the customer decided to purchase it, it was Grenville's job to dry it out, un-plumb it and pack it up ready for delivery. Many people who were contemplating a particular table lamp, or perhaps could not choose between several, wanted to see them lit, but they were not sold with plugs attached and it was time-consuming to wire them up. Grenville decided to create a rack with several lamp holders on so that any lamp could be attached and switched on.

The blacksmith's shop in Kenwyn Street was owned by Frederick Woodward Mitchell, a Master Farrier and general smith who set up his business after the First World War. His sons, Fred and Byryn, also worked there, and it proved hard work for men of small stature. Because they worked in a reserved occupation, they continued smithing all through the war years, mending things like farming equipment to make them serviceable to grow food to feed the people. One of the public information films that was broadcast during the war featured commentary from a man with a 'cut-glass accent', advising farmers to look after their old harrows by getting them mended and put to work. Several farmers rushed into the forge on market day, telling the smiths that they did not have any harrows

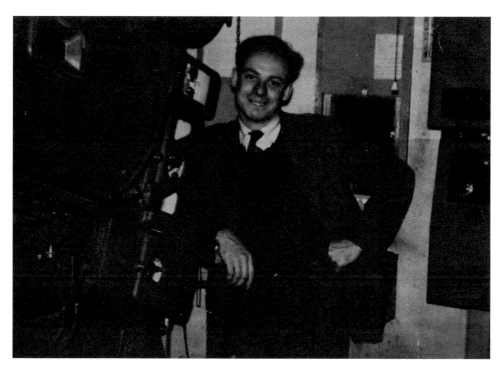

Grenville Pehaligon, cinema projectionist, pictured working at the Plaza Cinema.

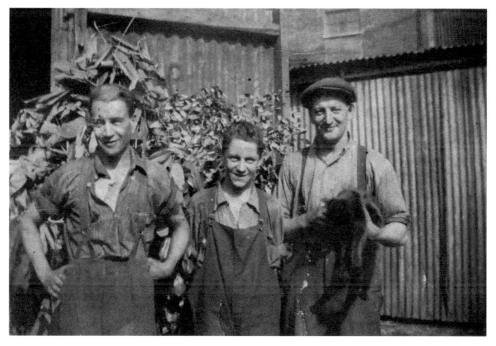

Fred Junior, Byryn and their father Frederick Woodward Mitchell (Fred Mitchell) take a break outside their blacksmiths shop.

and didn't know what they were anyway. Fred senior said 'Arras boys, arras', and daylight dawned across their faces.

It was fairly common for farmers to drop off items at the market to be mended and collect them before going home. Often, after a catch-up with his friends in the pub, the farmer would direct his horse to the forge, where the repaired equipment would be loaded onto the cart by the blacksmith who, noting that the farmer was nodding off, would slap the horse on the rump and send it on its way. Horse and passenger always arrived home safely.

In 1844, Pydar Street consisted of a large number of shops of various trades, many of which would not be found today. Ashley Rowe informs us that there were eight different shopkeepers trading in groceries and sundries alone, two cabinetmakers, one carpenter, three tailors (one of which was a dyer) and various hatters, including two milliners and a staymaker. With nineteen different shoemakers in the town, the two Pydar Street shoemakers had considerable competition. At least three tobacco pipe makers were based in Pydar Street, including Samuel Rundals and George Wakeham. In 1971, excavations unearthed a number of clay pipes, one bearing the initials G.W, likely to have been produced by George Wakeham or his son. Other articles discovered were some wig curlers made from the same pipe-clay material, a sideline pursuit of the pipe maker. The last

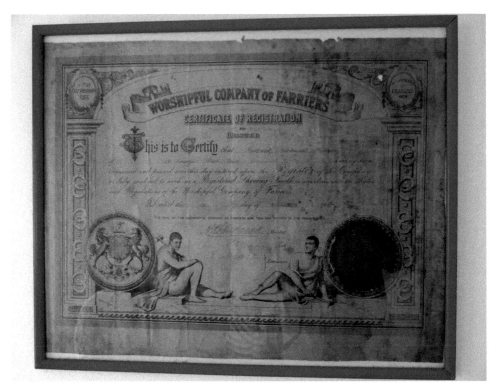

This certificate was awarded to Fred Mitchell on becoming a Master Farrier. During the First World War, while serving in the army in France, he often had to cold shoe horses because there was no forge.

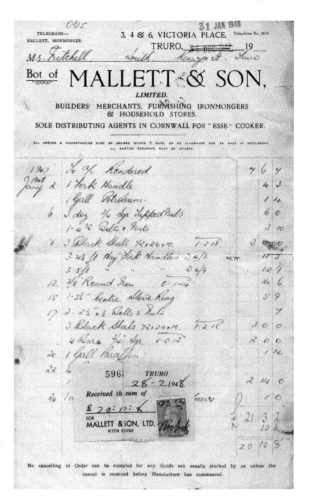

This 1948 Mallett's Home Hardware receipt lists items purchased for the blacksmiths forge. We note that the Mallett's address is correctly named Victoria Place.

tobacco pipe manufacturer recorded in Truro was Mrs Jane Cock, and when The Red Lion Hotel was demolished in 1967, a pipe bearing her name was found.

The present St Mary's Primary School is situated in the Trehaverne area of Truro, but up until the late 1960s the school was based in Pydar Street. In those days, teachers tended to stay at the same school for most of their working life, and consequently often taught more than one generation of pupils from the same family. One such teacher was Miss Merryfield, loved by many scholars despite the fact that her facial appearance was likened to a pantomime dame. With bright red lipstick coated thickly across her mouth, and bright pink cheeks framing her round face, the colours clashed against her ginger hair, immaculately styled in furrows and not dissimilar to a ploughed field. Every morning after prayers, while seated at their desks, Miss Merryfield instructed the children to close their eyes and put their heads down against the table. A few minutes later, they were allowed to open their eyes. However, one child hadn't resisted the urge to peep, so the secret was out: her hair wasn't real. The wig was removed, revealing a bald head and making the dear old lady look quite scary.

Cruro Cathedral, from N. W.

A picture of the local convenience stores in Pydar Street after 1910.

DID YOU KNOW THAT?

When the Dominican Friars came to Truro, it's believed that they founded the pottery situated in Chapel Hill. The clay in Boscawen Street was originally ideal for this purpose, although in later years clay from St Agnes or north Devon was used. The remains of a late seventeenth-century kiln were discovered in 1968 while the foundations of a new one were being laid. Many people remember it as Lakes Pottery, which is what it was known as when Mr Lake and his wife owned and ran the business. Specialist tools required by the wheelman comprised a selection of flat spoons made from iron with a hole in the centre, which allowed them to grip the slippery clay. They were made by Mr Mitchell the blacksmith in nearby Kenwyn Street.

During the Second World War, the theatre at Redannick was an egg-packing factory.

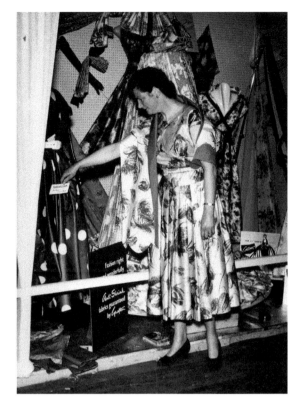

Right: Miss Martin purchased fabrics for Robert's department store before it sadly closed.

Below: Local ladies modelling the latest gowns of the era for a Robert's fashion show.

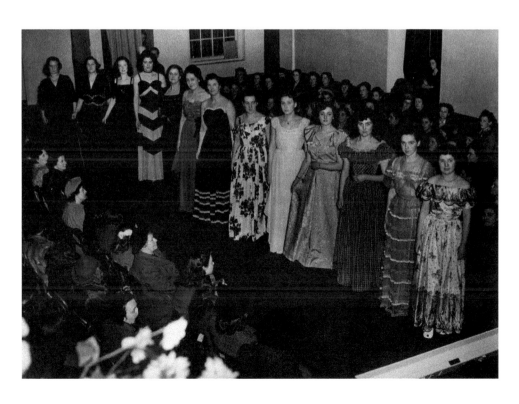

5. Calling for Help

Law and Order

In 1696, a young girl called Mary Rogers had her Christmas ruined. She was visiting the town from St Stephen-in-Brannel to sell her potatoes, considered a luxury in those days, hoping to fetch the best price. Wearing a large cloak, she was considered suspicious by Mr John White, a saddler going into the Market House. After a piece of linen, 12 yards long, fell from under her cloak, she tried to run off but was caught and taken to the home of Mayor John Foote. There she spent Christmas in custody and was committed for trial two weeks later. It's not known what became of Mary, but for a crime such as this the penalty could have been death, or deportation to the plantations of America.

Before the advent of the Cornwall Constabulary in 1857, Truro was policed by the Borough Force. Times were different then, and so were crimes, as can be seen from the following entries taken from the local charge books:

- 11 October 1846: James Lampshire, a labourer in Redruth, was arrested on suspicion of stealing a black mare. He was sentenced to ten years transportation.
- On 18 December 1847: William Hocking, the younger from St Clement's Churchtown, was arrested on suspicion of stealing confectionary – some rock – the property of

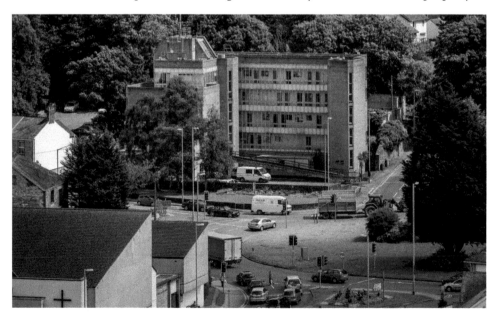

The old police station of the 1970s was accidentally built back-to-front and office doors exposed. Sadly, it was demolished.

George Wyatt, confectioner of King Street. He was convicted and sentenced to be whipped. The witness was a servant of Mr Wyatt named Mary Sweet.

- 27 October 1851: John Flinn, a young labourer of Truro aged twenty-one, stole a silk handkerchief from hatter Richard Robins. Richard Bartlett, a tin plate worker, was charged with aiding and abetting to rescue the prisoner from custody. Flinn was given seven years transportation and Bartlett was committed for trial.
- 25 April 1853: John Say, another labourer, was a regular offender otherwise known as Biddeford Jack. He was charged with being an imposter and receiving money under false pretences, by means of a begging letter containing false signatures. He was convicted of being a rogue and a vagabond and committed to the House of Correction for three calendar months.

Many people were convicted on a charge of 'wandering abroad in the streets of the said borough to beg or gather alms'.

Fire Safety

A disastrous fire occurred in Truro in 1868, discovered when PC Higman and Mr Hicks the Court Bailiff were visiting Boscawen Street and noticed the smoke. The constable blew his whistle, and a call was made to the fire brigade. Around £20,000 pounds' worth of damage was done, and it seemed likely that all the properties from the Royal Hotel through to the south side of Boscawen Street and west to St Nicholas Street would be destroyed, but somewhat fortunately it was only the backs of the premises that suffered and not the fronts. The alarm bell, which sat in the steeple of St Mary's Church, was rung, and a bugle call was sounded to alert the rifle volunteers who had been on parade earlier. However, it was remarked that the fire engines were too small, and even the largest could not throw water high enough to put out the flames; it was even suggested that a steam fire engine be sent for from Plymouth and brought down by special train. Luckily, there was no loss of life, but it was decided that a fire brigade be formed by townspeople for future emergencies.

The same year, 1868, the Truro Improvement Commissioners stated at their meeting that they were denied funding for the purchase of a steam fire engine. The insurance officers decided that the amount of water from a steam engine would cause as much damage to a property as the fire itself, but it was suggested by the mayor that the insurance offices were more afraid that people would rely on the ability of the fire engine to douse the fire instead of insuring their property.

Still, the fire engine committee reported that they had entered into a contract with Messrs Merryweather & Sons for a new thirty-man fire engine with all the necessary appliances. The mayor stated that the new engine would be ready by 1 August, when every arrangement would be made for an effective fire brigade.

Friday 14 July 1967 remains a memorable date for people living in and around the city, especially those who were in the Boscawen Street area on that fateful day. A runaway lorry, laden with 8.5 tonnes of concrete blocks, careered out of control down Lemon Street. The town was very busy with traffic and pedestrians, but thanks to the courageous driver, Mr Claude Gourzong, who flashed his lights and blared the horn as he shouted out to everyone that his brakes had failed, no one was hurt except him.

The notice says it all on this cell door.

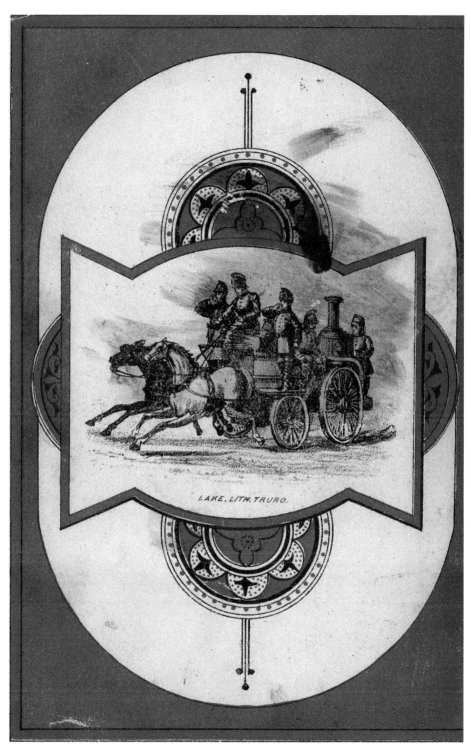

LAKE. LITH. TRURO.

This old fire brigade badge depicts a horse-drawn fire vehicle, adorning the cover of a menu card from an old fire service banquet.

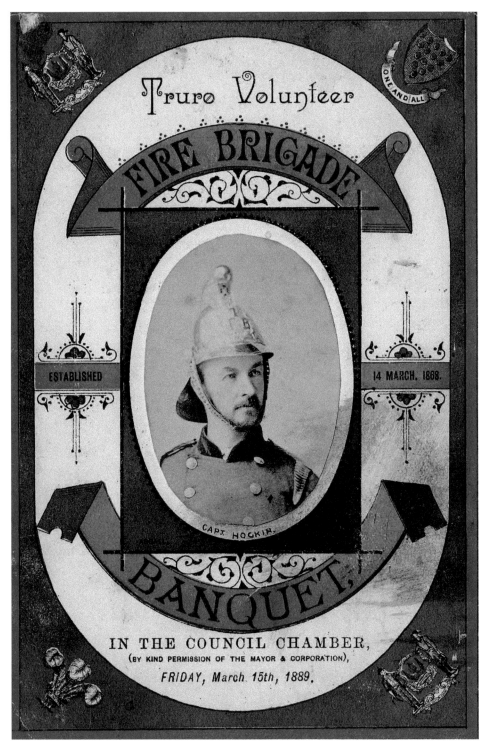

Truro Volunteer

FIRE BRIGADE

ESTABLISHED

14 MARCH. 1868.

CAPT. HOCKIN.

BANQUET,

IN THE COUNCIL CHAMBER,
(BY KIND PERMISSION OF THE MAYOR & CORPORATION),
FRIDAY, March. 15th, 1889.

ONE AND ALL

In 1889, Truro Volunteer Fire Brigade held a fine banquet in the Council Chamber. The cover of the menu card proudly displays their Captain Hockin.

An old telephone box, once a frequent necessity. Many of these now-disused phone boxes now function as small libraries or defibrillator access points.

A new postbox, situated nearby in The Leats. The relocated Post Office is in WHSmith.



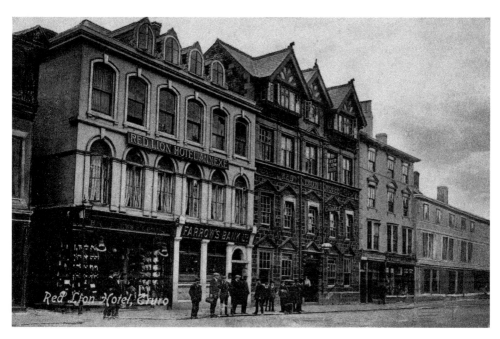

A group of people pose for the camera outside Farrows Bank and The Red Lion Hotel, a novelty for Truro in this era.

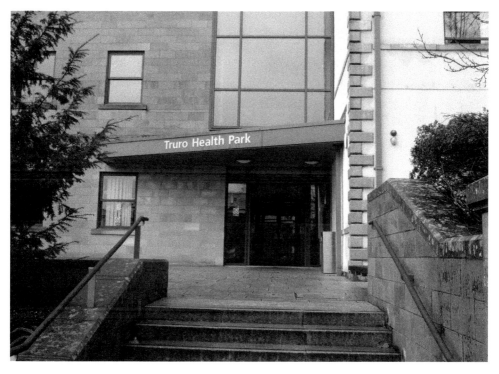

Truro Health Park, built on the site of the old City Hospital, was opened in 2010, replacing the old surgeries in Lemon Street.

The lorry smashed through a set of traffic lights and a pillar postbox and then ploughed into Truro's pride and joy, The Red Lion Hotel. Immediately, help was at hand: Dr Jago from one of the Lemon Street surgeries rushed to the scene, swiftly followed by police, firefighters and an ambulance. Assuming the worst, the hospital's sterile department was asked to supply an amputation set, but the only available set was waiting for an autoclave and had not been properly sterilised. This was a dilemma, but nevertheless it was taken to the crash scene in the hopes that, with all the dust and rubble, it wouldn't make a difference. Fortunately, it was not required, as the driver escaped with just a fractured left leg. Sadly, the elegant building had to be demolished and was replaced by a supermarket.

6. Places of Worship

Truro has had many churches, chapels and other places of worship over the years, far too many to incorporate them into this chapter alone.

Moresk is a name that is well known to local people. As well as various roads that use the name, such as Moresk Road and Moresk Close, Truro even had a Moresk Laundry at one time, saving busy housewives a task if they could afford it. It was one of the largest ancient royal manors in the county and, as was custom, it had its own church. In the 1100s, it was given to the priory of St Michael's Mount and gradually over time became known as St Clement's Church, with Saint Clement being its patron saint. The area of the manor, on the banks of the Tresillian River, also took the name of St Clement in preference to that of Moresk. Over one thousand years of worship on the site has resulted in a beautiful old church that has endured several necessary renovations. The list of vicars begins in 1261, and church information states that the base of the tower and the lower part of the north wall of the nave have been part of the building since the eleventh century.

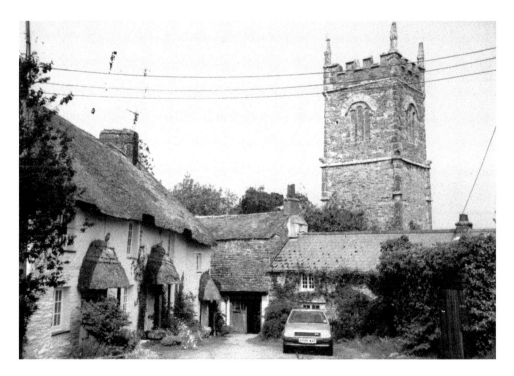

St Clement's Church towers over some thatched cottages, one of which used to be The Ship Inn.

DID YOU KNOW THAT?

As well as the Latin inscription, which translates to '*Igniocius Vitalis* Son of Toricus', the stone has ogham carved around the edges, an ancient Celtic script that was popular in Ireland.

The stocks that are in the porch of St Clement's were once used in New Bridge Street.

The Ignioc Stone, which commemorates a Roman Briton, stands proudly in the church grounds, having been moved from a less important position as gatepost for the vicarage, where it was of service for many years.

As the population increased and more people lived in the Truro area of St Clement Parish, a chapel was built to enable those who could not make the walk down to St Clement to attend the church. This was the Chapel of St Paul, and the foundation stone was laid in August 1844. By 1873, the chapel needed much repair, so in 1883 the foundations for the St Paul's Church we know today were built. Just as St Mary's was being demolished

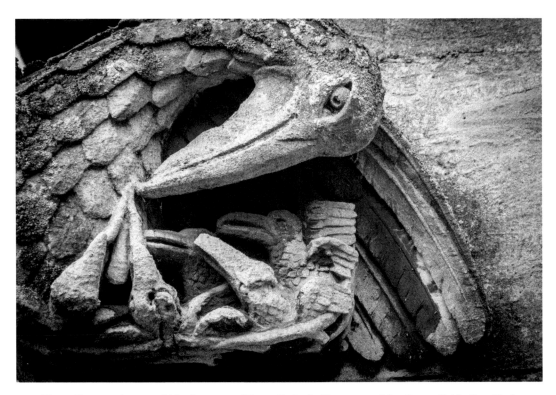

The pelican carving set within the stone of Truro Cathedral is a memorial to James Bubb, first Clerk of Works for the building. He sadly contracted typhoid in 1882 and died at the tender age of 39.

to enable the building of the cathedral, St Paul's was being built, and there was a plan to reuse the tower and spire of the old church on the new one, but this was eventually dismissed.

The price of the tower and spire was £300, and together with the cost of erecting it, it would be more expensive than building a new one. Instead of a spire, the architect J. D. Sedding began designing a tower that ended up not being completed due to a lack of funds. However, in 1909, Sedding's nephew Edmund adapted his uncle's plans, and the tower was eventually completed and dedicated in 1910. It is topped by a turret and three statues of Bishop Trelawny, Sir Richard Grenville and Sir John Eliot. Sadly, the church is no longer in use.

Truro Cathedral was the first in England to be built since that of Salisbury in 1220. Built in stages, it was first required that the old St Mary's Church be taken down, everything except for the south aisle that was to remain part of the new building and serve as the parish church. To allow services to continue, a wooden shed was purchased for £430 and furnished with items from the old St Mary's. Despite being extremely hot in summer and very cold in winter, this wooden cathedral was in use for seven years, until

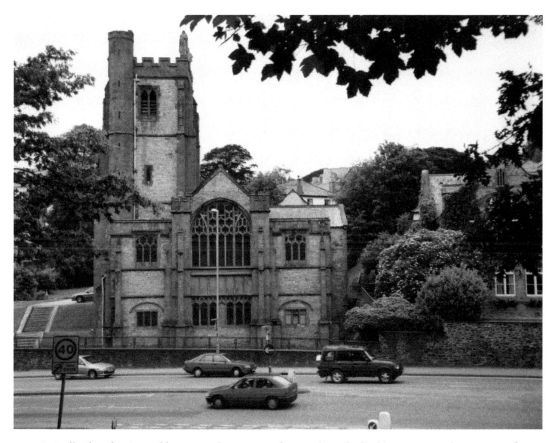

St Paul's Church, pictured here, is no longer open for worship. The building is currently in a state of disrepair and up for sale.

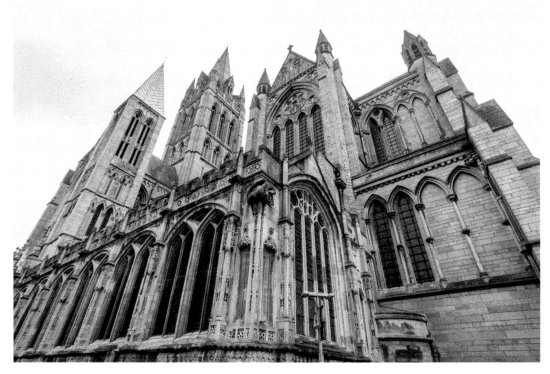

Styled with Gothic Revival architecture, Truro Cathedral was designed by John Loughborough Pearson, beginning in 1880 until its completion in 1910.

it was no longer needed and eventually sold. It became known as Smith's Cathedral Boot Works and was based in Drump Road, Redruth. It remained in use until 1981, when it caught fire.

It was on Christmas Eve 1880 that a new service, devised by Bishop Benson, was first used. It consisted of nine short lessons that were interspersed with carols and has become world famous and a feature of many festive celebrations. Not everyone realises that the service originated in Truro.

Recently, a popular fundraiser method for building renovations has been circulating where people have suggested selling roof slates, allowing for a dedication to be written on each one that's purchased. These slates would then be later incorporated into the roof; it's a nice thought that many dedications and messages to loved ones are within its structure.

When Bishop Bronescombe came to Truro in 1259, one of his tasks was to re-dedicate Kenwyn Church, the other main church of the city. It was already so old that it had either undergone major renovations or was partly rebuilt, but the church suffered again in 1860 when the tower was struck by lightning and had to be closed until restoration work was completed. A new window was installed in the church in memory of William Mansell Tweedy, and a celebration service took place at the reopening of the church on 15 May 1862.

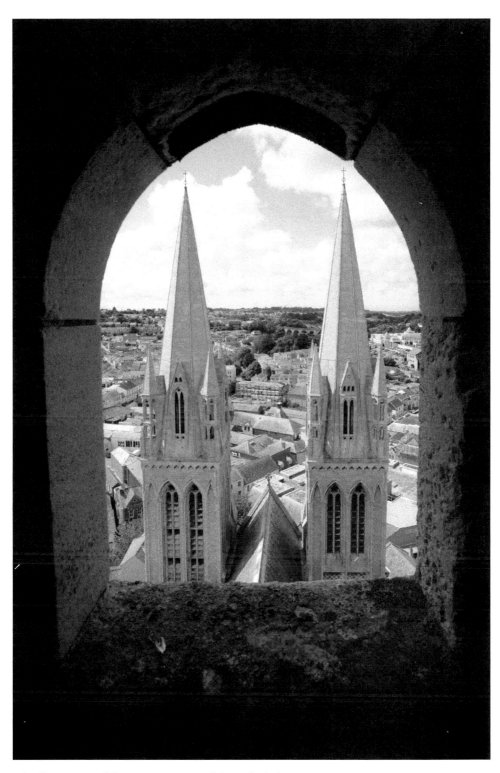

A bird's-eye view of the western towers of the cathedral.

A festive scene in Kenwyn. However, Santa seems to have forsaken his reindeer for a motor vehicle.

The Lychgate at Kenwyn has an old schoolroom above it which was in use from 1920. The pretty setting of Kenwyn Church makes it a favourite venue for weddings.

The old Baptist Church (*right*) designed by Philip Sambell is now an art shop and café. In recent years, the chapel building has been incorporated into the museum.

St Kenwyn churchyard is home to twenty-four Commonwealth war graves, and some of the young men buried there would have lied about their age in order to serve their country. It is also the resting place of Percy, Mabel and Margaret Mortimer and Alfred Edward Pentecost, who all lost their lives in the 1942 bombing of Truro. There is a quiet area at the bottom of the churchyard that is a burial plot for the sisters of the Epiphany, whose convent had been in Truro for many years. Clarice Mortensen Fowler, a well-known and respected Truronian, and her beloved husband rest here together with a whole host of local people stretching back over many years.

The Truro Corps of the Salvation Army who have occupied the Citadel in Kenwyn Street since 1882 were able to purchase the property outright in 1926, and on the August bank holiday of that year were honoured by a visit from their leader General Bramwell Booth.

The Methodist community in Truro met in several places over the years, often outgrowing their meeting houses and never having a permanent building that would accommodate everyone. When John Vivian died and his house was advertised for sale, the Methodists managed to buy it just before another interested party claimed it. Philip

Sambell was the architect of the new building, and the result was a classical structure that opened in 1830. In 2019, some of Sambell's descendants visited Truro and toured many of his elegant buildings before being entertained to refreshments in the Mayor's Parlour.

Another two religious buildings in Truro boast Sambell as their architect: St John's and the old Baptist Chapel in River Street, which now forms part of the museum cafe and also has an excellent art shop. St John's was built as a chapel of ease for Kenwyn, and the contractor was the architect's father, the senior Philip Sambell. The foundations were laid by Thomas Daniell of Trelissick, and under the stone a bottle was placed that contained a paper and coins.

The Roman Catholic Church has the unusual dedication 'Our Lady of the Portal and St Piran'. First venerated in Rome in the sixth century, it's possible that an intrepid seafarer from Truro gave thanks there and endowed a chapel with the same dedication on his return home. The Kremlin also has a reference to the same Portal, something that was introduced there in the seventeenth century. The icon in the Kremlin is known as Iverskaya and is often carried round in a procession or even taken to private houses. An excellent copy was smuggled out of Russia during the revolution and brought to this country, and it now lives in The Shrine of Our Lady of Walsingham. When the planned site for the new Roman Catholic Church was being

The Sunday school room of St John's Church stood at the junction of Lemon Street and Infirmary Hill. It has since been demolished, but is just visible on the left of the photo.

The new Roman Catholic Church, Our Lady of the Portal and St Piran, was opened on 17 May 1973. The previous church, designed in 1885 by Silvanus Trevail, was located in Chapel Hill.

prepared, a large piece of pottery was found depicting the head of a lamb, and beneath it was a spring that constantly spurted water despite any attempts to pump it away from the building work. It was eventually incorporated into the church and the well was covered with a slate lid.

During its construction, three assay cups were found beneath the Truro Tin Smelting Works. However, all that remains of the smelting works today is what faces Trafalgar roundabout.

For many years, there was a corrugated iron church at Buckshead and a mission church in Charles Street – both no longer exist.

As Malpas became busier and more people moved there, it was felt that this thriving village should have a church, as while there was already a Methodist Chapel built at Victoria Point in around 1850, there was only one hired room for Church of England members to use for worship. The church was built with the help of the vicar of St Clement's the Reverend A. P. Moore, a long-standing friend of Bishop Benson. Opened in 1852, a piano was donated by Mrs Charis Johnston, sister-in-law of the famous cricket commentator Brian Johnston, and was in use until the 1990s. The church, given the name

The Mission Church of St Andrew in 1882, became home to the services of a Russian Orthodox community from the mid-1980s until 2012.

Built in 1857, the congregational chapel and schoolrooms located in River Street were put up for sale in 1935 and were sold to the Rural District Council for the offer of £2,000. The ecclesiastical appearance of the building was changed when a fake Gothic window was removed, as were the two tall towers with spires.

At the beginning of the nineteenth century, a dentist called Charles Bate invited a group of people who had split from the congregationalist Bethesda Chapel as a means of offering services that were more inclined to their way of thinking. The congregation drifted away when Mr Bate left Truro, but the chapel is remembered through the street name, Tabernacle Street.

DID YOU KNOW THAT?

The top of the spire from the old St Mary's Church is now in the grounds of the cathedral. It once stood in the garden of the now demolished Diocesan House in Kenwyn, together with its cross, which was eventually placed on a sundial. The spire was erected on a base that bore the following words: 'High over busy Truro town of Mary's church this topmost crown'.

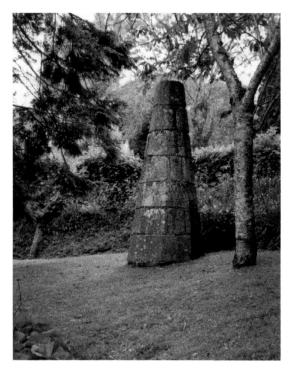

The spire from the old St Mary's is now situated in the grounds of the cathedral, near to its original position. It was built in 1765 and was saved from demolition.

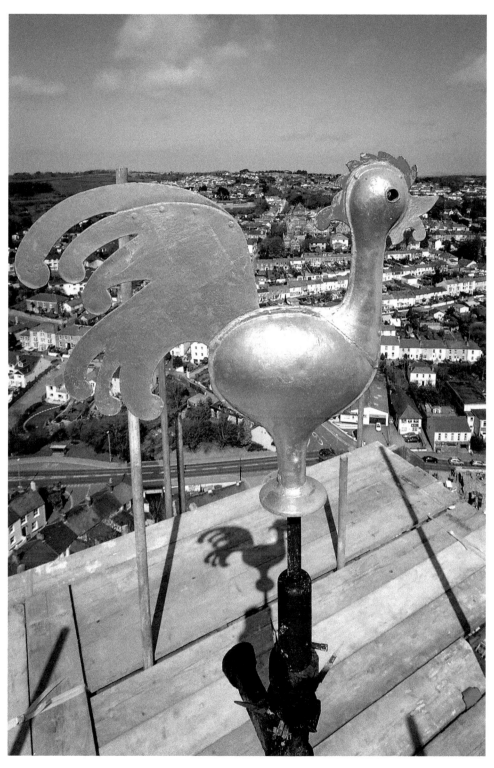

The cockerel weathervane situated on the central spire of the cathedral is visible from all over the city.

7. That's Entertainment!

It was in 1789 that Truro's Assembly Rooms had just opened outside the church; the money to build it was raised via tontine. Twenty-eight shares were on offer at £55 per share, with the purchasers nominating another person. As long as the nominated individual was alive, the investor shared in the financial running of the building, shouldering any debts or profits that should occur. When it was realised that everyone had forgotten to nominate someone, they rectified the mistake and eventually Eliza, the granddaughter of a man called John James, inherited in 1889.

The opening of the rooms was a grand affair, with the famous actress Sarah Siddons performing. Over the years, established names visited Truro to delight the crowds. One such visitor was the American dwarf General Tom Thumb, who came with his wife and her sister Miss Minnie Warren. The fourth member of the group was Commodore Nutt;

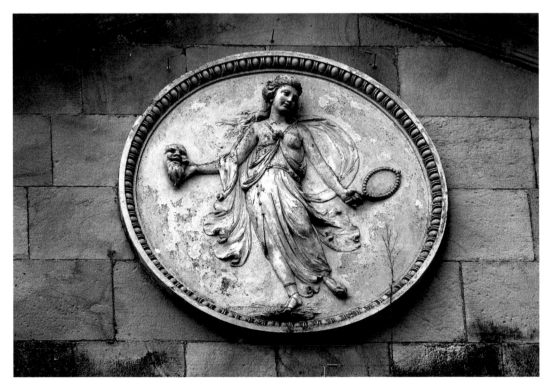

A clear view of Thalia. The plaque on the old Assembly Rooms looks in better condition these days now that the chimneys use smokeless fuel.

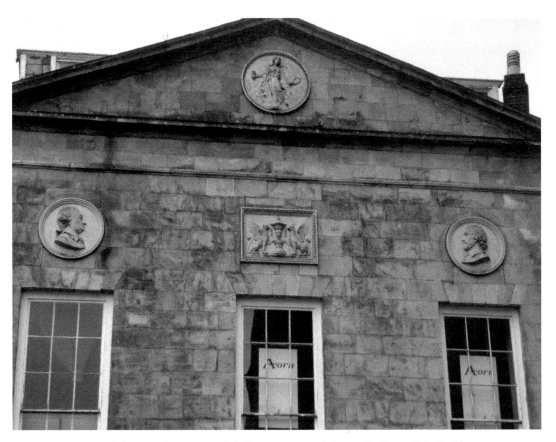

The Wedgwood plaques of Garrick and Shakespeare join Thalia on the front of the building.

according to reports at the time, their act was to sing and dance together. The General had a custom-built coach pulled by miniature ponies and was often spotted driven round by the coachman with his footman.

Another prestigious performer was Madame Angelica Catalini in 1813. She appeared at three concerts, and it seems that most of the Cornish gentry made sure to be in town for those weeks. It also happened to be the Cornwall Grand Music Festival.

Joseph Emidy was another visiting entertainer, and accounts vary as to his place of birth. According to Ashley Rowe, the first recorder of the Truro Old Cornwall Society in 1936, Emidy was born in Lisbon in 1775, but others suggest it the was Guinea Coast. Edward Pellew was in Lisbon awaiting repairs to his ship, *The Indefatigable*, when he became aware of Emidy playing the violin in the opera. The day before his ship was due to set sail, he kidnapped Emidy and forced him to play music to entertain him on his voyages for the next five years. When Pellew was due to change to a different ship, *The Impeteux*, he wasn't allowed to take his crew with him, so he abandoned the musician in Falmouth where it didn't take long for him to establish himself as a teacher and performer of various instruments: the violin, the flute and the guitar. He also managed to

find himself a wife and married Jenefer Hutchins in the parish church in 1802. Eventually, he moved to Truro, where he lived for the rest of his life. He died in 1835 and is buried in Kenwyn churchyard.

For many years, Emidy was the leader of the Truro Philharmonic Society, made up of gentlemen amateurs who were 'highly respectable' and aided by professionals. Performing an astounding thirty concerts every year, their usual venue was the town hall, but they were moved to the assembly rooms due to a lack of space. While the rooms were used for other purposes, music meant a lot to the people of Truro. In 1811, a grand ball began with eighteen pairs of dancers, but the popularity of the event meant that some young ladies went without a partner and had to sit and watch. The following month, the committee made an effort to acquire more men, but now the initial problem had been reversed. A notice from the committee in 1810 declared that the assemblies were to be held every month 'at the full of the moon'.

By the time Eliza inherited the assembly rooms, the venue had been outgrown, and the Palace Buildings overlooking The Green were taken on as the new entertainment rooms which were built in 1867.

Entertainment was not just about concerts and balls; there was a cockpit in what is now known as The Leats, and another outside the Fighting Cocks Inn. Sailing also featured highly on the list of relaxting pastimes, and there used to be races for years before they

The Palace Building used to function as a cinema and bingo hall. These days, the bus station is situated at the rear of the property.

The room with the ornate window once housed Bishop Phillpotts Library, containing many rare and religious books. They have since been moved to the Old Cathedral School.

slowed down and gradually picked up again in 1816 in the form of the Regatta. In 1846, the competition was interrupted by the arrival of the Royal Yacht bringing Queen Victoria on a visit to Truro. Although she remained aboard with Prince Edward, Prince Albert came ashore and visited Pearce's Hotel. As a result of this visit, the hotel became known as The Royal, the farm at Shortlanesend that provided the food for the hotel became Royal Farm, and the boat racing became Truro Royal Regatta.

During the middle of the nineteenth century, local fairs brought great delight and entertainment to the people of Truro and the neighbouring villages. However, the attractions were very different from those of our modern day.

At Whitsun, Wombwell's Menagerie would arrive at High Cross with an extremely brazen brass band. The chief item of their repertoire was a song called 'Vital Spark', with the growls of the entailing wild beasts often responding to the vibrant music. Later, the focus moved to Boscawen Street, where Ordes and Morelands provided theatre and pantomime performances.

Various smaller fairs and travelling shows would make occasional visits to Truro throughout the year. One of the main attractions was the Mid-Lent Fair, sometimes known as the Glove Fair. In 1812, Polito brought his Royal Menagerie to this fair, and the great leather glove was mounted on a tall pole in King Street. Tradition has it that the glove, the symbol of authorisation, was stolen from Penryn.

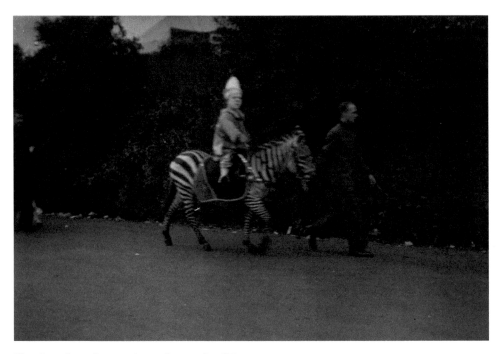

The circus brought great joy to the people of Truro.

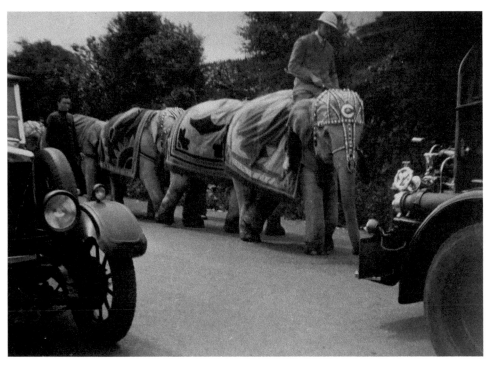

It was around the 1920s when these elephants were pictured in the town. They sometimes bathed in the Mill Pool.

The event was widely advertised, boasting an elephant, a lion, a zebra, kangaroos, an African ostrich, a pelican and, to the awe of many of the locals, black swans, which were rarities of the new world. These travelling menageries were often well attended.

DID YOU KNOW THAT?

Buffalo Bill came to Truro in 1903 and alighted from the train at Newham, a station that has long since disappeared. He had been to England several times before but had never come to Cornwall. He had over one hundred cowboys with him, all of them riding their buffalo-hunting horses, alongside acrobats and Native Americans.

The Plaza and the Palace were the main cinemas in Truro, but during the 1950s the Gas Showrooms in Boscawen Street often opened their doors for evenings of free films concerning travel, foreign cultures, and other similar topics. A group of ladies known as the Women's Gas Federation often met there to watch cookery demonstrations, and on occasion a reputed company would send along a representative to advertise their products; one such company that proved to be a great success with the women was Branston Pickle. Many used the Gas Showrooms as an opportunity of advertising

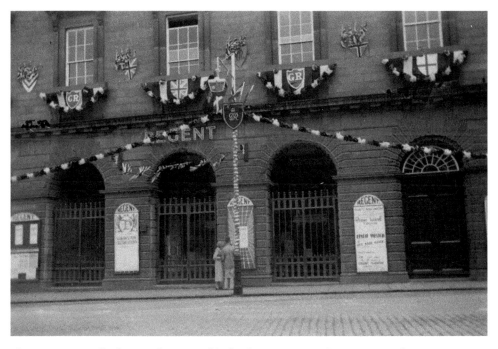

The Regent is royally decorated, presumably for the coronation of King George VI.

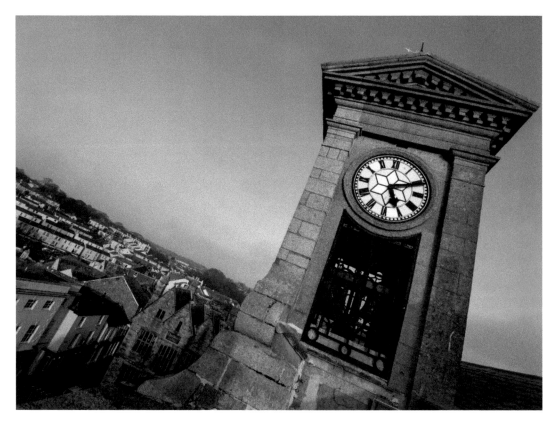

Taken from a rooftop in Boscawen Street, the bells in the clock tower are just visible. Below, the Tudor-style buildings is Charlotte's Tea House, the favourite tea rooms of the city.

alongside evening events, usually promoting the latest gas appliances. On one such evening, while Mr Jacobs was attending a film, he took notice of a poster that advertised a 'Bathing the Baby Competition', which was to be held the following evening at the City Hall. First prize was a new Ascot gas water heater including all the fittings, which would serve to provide a household with instant hot water.

The Jacobs' family home in Boscawen Row was a two-up, two-down cottage that had neither hot nor cold water indoors – only a cold water tap in the backyard. Having a wife and five young children to look after, he thought he would give it a go.

That evening the City Hall was busy, and there was a stage prepared with the necessary bathing equipment and a baby doll. There was a judging panel made up of midwives and nursing professionals armed with clipboards and pens.

When the contestants entered, Mr Jacobs was a little unnerved to find he was the only man competing against eleven women. By the next and final evening, the judges had narrowed it down to just three contestants: Mr Jacobs and two women, one of whom was Mrs Tregellas, who owned the nearby fish and chip shop. The lady felt sure that she was going to be the lucky winner so, after she made her final attempt of

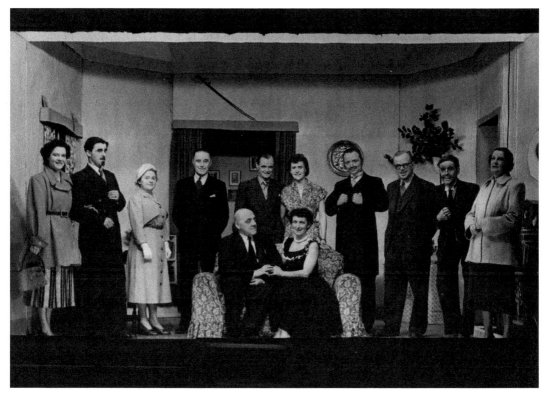

The Phoenix Players pose together after a performance of *Will Any Gentleman* in St George's Hall. Jack Parnell is pictured standing behind the seated couple.

bathing the baby, she called out to the judges that she was leaving the hall for a while to go back to work and declared that she would be back later to collect her Ascot. It was to the amusement and delight of many in the hall that the coveted prize went instead to Mr Jacobs.

The whole family were overjoyed when the Ascot hot water heater came home, together with a beautiful bouquet of flowers for Mrs Jacobs who had no idea her husband had entered the competition. You see, he'd been keeping it all a secret.

DID YOU KNOW THAT?

The front of the City Hall facing toward Boscawen Street was at one time home to the Regent Cinema. Not only did they show films, but it was also a popular dance venue, and in winter an ice rink was installed to allow the people of Truro the opportunity to skate.

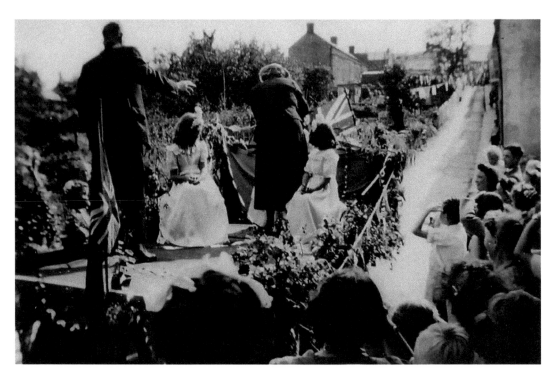

A carnival held in Boscawen Row in the late 1940s. The long washing lines of large families are visible in the distance.

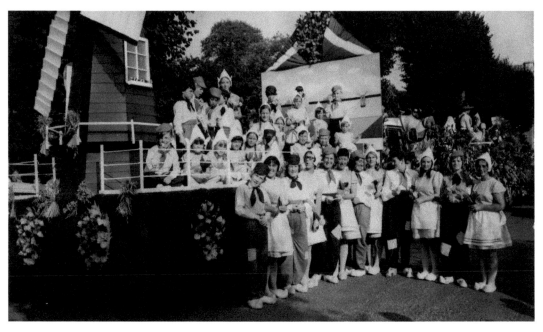

Cornish Crescent, Malabar entered the carnival with the title *Little Holland* – that year, they won the prize for the best float.

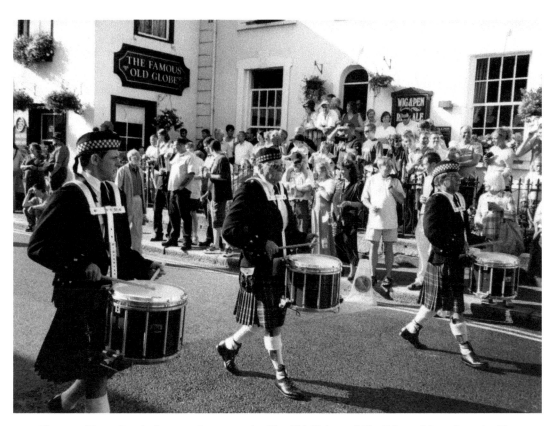

The 2003 Truro Carnival procession passes by The Old Globe and The Wig and Pen. Organised by the Truro Lions Club, this annual event always draws a large crowd.

8. Eat, Drink and Be Merry

In his writings, Ashley Rowe mentions a Lord Truro, the existence of whom was a mystery to most people. However, Rowe deduces that Thomas Wilde was born on 7 July 1782, the second son of a Thomas Wilde senior, a London solicitor. He attended the St Paul's School, London, and at the age of fourteen he was articled to his father and remained in the same profession for all his career. He acted as junior barrister in the defence of Queen Caroline, which was an extraordinary trial that took place at the House of Lords. She was separating from her husband, George IV, the Prince Regent, in 1814, and the whole trial lasted forty-five days. Despite his speech impediment, Thomas progressed to Sergeant in Law, then Kings Sergeant and then on to Lord High Chancellor. He received a barony and became Baron Truro, of Bowes in the County of Middlesex. Upon his death, Wilde's nephew inherited the peerage, which then became extinct.

Baron Truro also had a part to play in the turtle soup case of 1827. John Stevens of The Red Lion sued William Pearce of Pearce's Hotel for £4 18s, the value of the soup that had gone missing. During the Truro Races of 1825, it had been dispatched from Bristol and intended for The Red Lion, but it never reached its destination. However, it's believed to have landed on the tables of Pearce's Hotel.

In the 1970s, Truro had a fancy restaurant in Pydar Street called Rendezvous des Gourmets. A page from an old guide survives and gives us an insight into what would have been on the menu. The owner, Mr Solamito, served up a variety of soups, such as *Velouté de crabe au riesling* and *Velouté Doria* for 27½d. The book states that 'his ways with local mussels and lobster are fervently admired, as are [the] green cannelloni and pilaff de volaille'.

John Cooper Furniss had a bakery in King Street, which is fondly remembered for its gingerbread and Cornish fairings. However, he moved to Church Lane when the cathedral was being built, where he was ideally placed to sell food to the hungry men working at the site. He had plenty of business connections around the town, including the buffet at the railway station, which he kept supplied with food. Mr Furniss died in 1888 and the town maintained a delicious aroma until 1988 when they moved to Redruth under the new name of Furniss of Cornwall. Many school trips entailed visiting the factory and watching the name 'Truro' being incorporated into sticks of bright-pink rock.

For many years, the People's Palace was a leisure centre. Given to the city by the wife of the Reverend Joseph Cockin, a Methodist minister, Mrs Cockin was concerned that young people of Truro should have somewhere to relax and spend their free time. Donated around 1900, she decided not to put an age limit on those who wished to use its facilities, but she was adamant that there was to be no drinking alcohol or gambling on the premises.

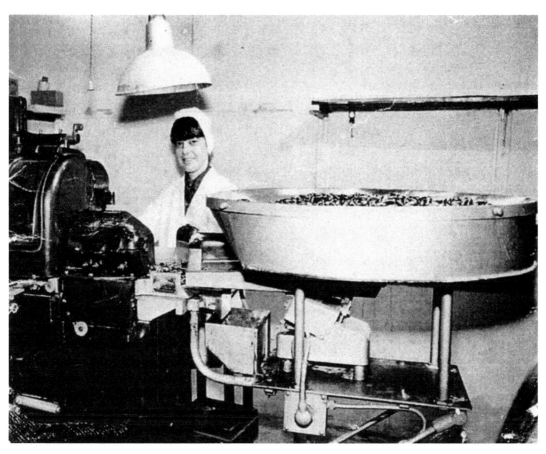

Miss Kent busy at work in the old Furniss biscuit factory in Truro.

Many games and activities took place there, including boxing, snooker, skittles, gymnastics and various other sporty pastimes. Music and singing were also enjoyed there, and the People's Palace Male Voice Choir won the Cornwall Music Festival in 1930 and were awarded a copper shield. Their conductor was Mr Bertram Lightbown.

It was recently discovered that Harold Hay, a leading presence in the Arcadians *c.* 1930, has passed his talent on to his granddaughter, who is part of the modern group Acoustica. Edwin James Paddy and his orchestra were in great demand to perform at tea dances and at most of Cornwall's great houses. The Amazon Dance Band also played in the Truro area, with Jack Parnell on the violin. Brass bands were popular, including the Duke of Cornwall's Light Infantry volunteer brass band.

Throughout the 1950s, a quick meal often meant popping to the local fish and chip shop for a supper wrapped in newspaper. Sometimes, just a 3*d* bag of chips and screeds (loose pieces of batter, sometimes called scriddlings), served up in a cone-shaped bag and saturated in salt and vinegar, was ideal to eat on the way home. Lang's, a takeaway in River Street, had the enterprising idea to add fried chicken to their menu, but they needed a poster to advertise. Mr Jacobs, who already had a gallery of amusing drawings on display in Pascoe's

The People's Palace Male Voice Choir proudly display their winning copper shield.

fish and chip shop, was skilled at drawing, so Lang's asked him to produce it: the poster illustrated a chef wielding an axe, in hot pursuit of a runaway chicken, and sales went up.

There used to be over 106 public houses in Truro. In 1903, the Royal Standard in Kenwyn Street, which also had a musical connection, put up for sale 'an American organ in splendid condition'. At £4, it was said to be a genuine bargain, and the prospective purchaser should apply to R. Venton for any enquiries.

Not far away was Truro Cemetery, of which the sexton, wearing a black cape and Homburg hat, often visited the Witches Parlour bar and made a strange toast to the good health of the people he had buried that day. On a happier note, the Royal Standard held a harvest festival every year, celebrated with a bread loaf in the shape of a wheat sheaf, paid for by a Mr Fred Mitchell senior.

Many pubs had their names changed, but sometimes their owners moved to new premises and kept the same name, which always caused confusion. The name Western Inn was given to 61 Kenwyn Street in 1823 and then to 55 Kenwyn Street in 1839. It was best known much later, when it sat on the corner of Kenwyn Street and Little Castle Street. When Ginnett's Circus visited the town in 1885, the stables of the pub became a temporary home for a camel and an elephant. Unfortunately, they broke into the pantry and ate everything.

Hogs pudding was a delicacy in Truro, especially when made by Crowle & Moss in Pydar Street. Resembling a large sausage, it can be sliced and eaten hot or cold. When the

Once known as the Park Hotel, The Heron Inn at Malpas is now a popular restaurant.

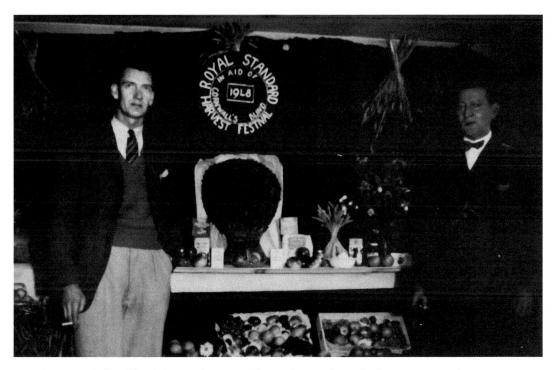

Gerry Mitchell and his father Fred pose together at the Royal Standard Harvest Festival.

This building, once known as the Western Inn, was a recruiting office for the armed forces for many years.

Back to the days when butchers dressed their windows.

This particular butcher shop was irocnially owned by the Mutton family.

shop unfortunately closed, the butcher Arnold Hodge took on this important role. Next door to Crowle and Moss in Pydar Street was Myners, the popular local pasty shop, often considered the next best thing to those home-made.

DID YOU KNOW THAT...?

Market Day fell on a Wednesday and was traditionally considered pasty day in Truro. People were often found eating this delicious pasty out of a paper bag, often to be jokingly asked if they'd cut their hand as tomato sauce dripped out of the bag and down their hand.

At one time, Trennick Mill, now a restaurant opposite Boscawen Park, was known as The Junket House, in reference to the dish of sweetened and flavoured curds of milk. A Mr and Mrs Percy of City Road in Truro supplied the rennet required for making junket, and Percy's Essence of Rennet became a worldwide brand.

During the 1960s, milk machines appeared on the streets. If you had run out of milk and the shops were closed, it was handy to put 1s into the machine in exchange for a pint carton of milk. There was also a choice of flavoured milk – strawberry or chocolate – which was similar to milkshake. There were two machines in Truro, one outside Lang's in Lemon Street and the other outside Clemens Post Office near Boscawen Bridge.

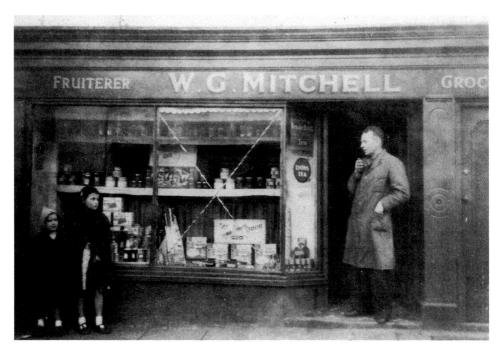

Charlie Mitchell, pictured in the shop doorway, managed his nephew's grocery shop in Kenwyn Street.

Although the name of this pub changed to the Crab and Ale House for a short time, it has since reverted to its original name.

9. Beyond the Boundary

In 1830, Calenick became the scene of a murder. Grace Andrew, the elderly wife of a workman at the smelting house, was found dead in her cottage. Although the locals tried to investigate the affair, it became necessary to call one of the Bow Street Runners, considered the first professional police force. Eventually, a Peter Mathews was arrested and faced trial in the Bodmin Assizes, but although he'd be detained before, he adopted an alibi, and the Judge didn't have sufficient evidence to convict him of the crime. A free man, Mathews joined the Royal Marines and escaped to Rio de Janeiro, where he eventually feigned illness and confessed to the murder. His plan had been to return home on account of ill health, but when he arrived in Falmouth on the *Packet Eclipse*, he was met by two Kenwyn constables, Rowe and Rapsey. He stood trial once more, this time at Launceston Assizes, but again the verdict was not guilty. We will never officially know who murdered Grace Andrew.

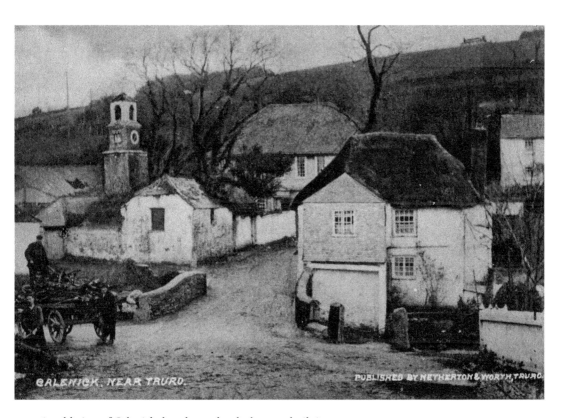

An old view of Calenick that shows the clock tower built in 1705.

Three Eyes Chapel

William Trewartha Bray was born in the village of Twelveheads near Truro on 1 June 1794. Raised by his Methodist grandfather, he became known as Billy Bray, the famous Methodist preacher. However, like many Cornish men, he'd worked in the tin mines, and during the early part of his adulthood he was known for drinking, fighting and a range of other sins.

In 1821, he married Joanna and had seven children.

After reading John Bunyan's book *Visions of Heaven and Hell*, he became a converted Christian and famed for his eccentric and enthusiastic methods of preaching, singing and dancing.

Billy became so popular as a preacher that he was eventually able to raise the money to build three chapels, one of which became Three Eyes Chapel in Kerley Downs, where the windows were believed to resemble eyes. The other two were Bethel Chapel in Twelveheads and the Great Deliverance Chapel in Carharrack.

When building the Three Eyes Chapel, he needed a pulpit. He spied a cupboard at auction that he thought ideal to convert but was sadly outbid. Not one to give up, he

Billy Bray, the Cornish evangelist.

saw the cupboard being carted uphill to the home of its new owners and followed it. The man who had bought it realised that it wouldn't go through the front door and flippantly announced to Billy that he was going to 'scat it up' for firewood, but Billy took the opportunity to offer what he could afford – the man accepted, and thus Billy acquired his pulpit.

DID YOU KNOW THAT…?

The earliest reference of 'scat up' was found in 1842, while the Devon and Cornwall Militia were at Plymouth. At the end, all the troops were dismissed and all followed order, with the exception of the Corps West of Truro. Astounded by this, the General asked the officer why the troops did not obey his command, and the officer explained that the troops did not understand: 'If you will allow me sir,' he said. Turning to the Corps, he shouted, 'Company scat up!', to which they did.

Billy Bray confessed that there were many stories of his earlier years that, now a committed Christian, he preferred to keep a secret. He died in 1868.

The Church at Old Kea
Legend has it that St Kea was a young Irish monk who was so distressed at witnessing his fellow monks sail away to heathen England that, while praying, he fainted and awoke floating on the granite stone on which he'd been praying. He washed up ashore on a creek of the River Fal and decided to set up a monastery; for many years, a large block of granite could be seen on the riverbank and was thought to be his makeshift boat. A saying grew out of this myth that if anyone who went out to sea in an unserviceable boat may as well have taken a voyage with St Kea.

Over the years, a small church began to form there, but it stood at the extremity of the parish, far away from most of the population that lived in the area. In 1802, a new church was opened at Kea, All Hallows, for the purpose of being more central to the parish. However, it wasn't built well and was replaced in 1895.

When the church at Kea was built, some of the stone that was acquired from the old church was sold, while some was used to build the local poorhouse, which was later used as a schoolroom or place for public worship. The Reverend Murray, the curate in charge, conceived the idea of turning the building into a mission church by adding a chancel and south aisle.

While the building work was underway, the shaft of a cross was found in the old foundations. It is now sits in the churchyard and is thought to have been a preaching cross from the founding of St Kea's Monastery, or perhaps even pre-Christian. There's a

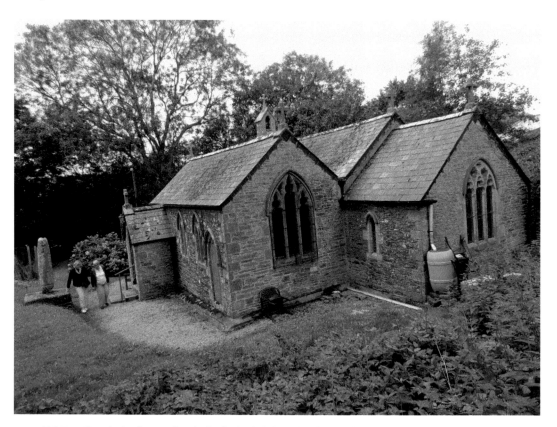

Old Kea Church displaying the shaft of what's believed to be a Celtic cross.

circulating rumour that it might be what's left of an old parishioner turned to stone for being more partial to rum than water.

In 1858, there was another legend attached to the cross. The story begins eighty years before, when a farm labourer had a dream that a crock of gold and silver coins was buried beneath the church. Having had the dream on multiple occasions, he arranged to meet up with another local farmer and promised to share whatever treasure might be found. Upon digging, they uncovered a four-legged iron crock (they usually had three legs) which stood above a circular stone. However, the crock was empty, and both farmers lamented this rather disappointing fact. Strangely, after the incident, the farmer became rich when a distant relative died and left him some money. With it, he bought one hundred sheep and made the labourer his shepherd, but the sheep swiftly sickened and died. Their mangy skins were also worthless, marked all over with what looked like red-hot coins. It's said that, from this point forward, no animal could ever thrive with the farmer unless it was marked with a cross and keys.

This story was known to William Hals, a local historian born in 1655, who would've pre-dated the previous tale. Hals was told by his informant that he was shown a crock at Goodern, and that the crock was dug up on a stormy night of rain and

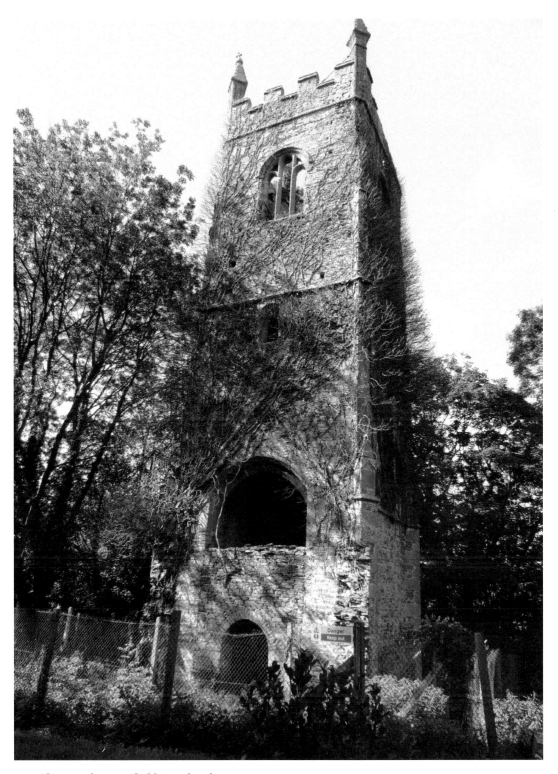

The ruined tower of Old Kea Church.

Above: An inscription in one of the church windows memoralises the curate J. W. Murray.

Left: A pretty stained-glass window in the church.

lightning. Apparently, it contained so much gold and silver that the finder became a freeholder and a gentleman. In the play *Beunans Meriasek*, Goodern is the home of the tyrant Tuedar. Perhaps local myth and history combine to form this Cornish play of miracles.

DID YOU KNOW THAT?

Woodcock Corner, situated between Truro and Tresillian, is named after a stagecoach horse that died there.

While travelling along the quiet lane between Coosebean and New Mills, it may be a surprise to see an old 1952 Land Rover that appears to be growing out of a nearby hedge. The owner, mechanic Frank Bullen, says that he parked it there when it broke down in the 1980s. He bought the vehicle second-hand for £50 and was told it had been to Cape Town and back, believed to have clocked over one million miles. For the fifteen years it

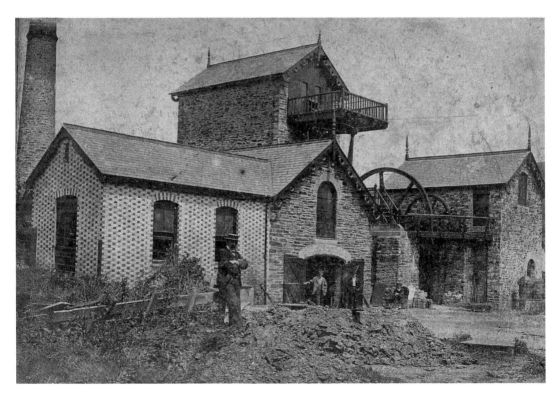

The pumping station of Truro Water Board has since been demolished and replaced by a ticket office at the Tregurra Park and Ride.

Since this photo was taken, the Land Rover is so overgrown that it's now barely visible.

was in service, it was his only method of transport, but he'd been so busy repairing other people's vehicles that he never had time to repair his own.

This unusual sight in the hedge has acquired global acknowledgement through the internet, and many people have taken photographs of it – some Americans are reported to have been so amused that they wrote poetry about it.

A fascinating second-hand shop, once the tollhouse at Tresillian, is now a popular attraction for visitors.

The Wheel Inn, a Grade II listed thatched building, is likely to date from the fourteenth century. It is believed to be the headquarters of Thomas Fairfax at the time of the English Civil War.

10. Ghouls and Ghosts

The fascinating tale of the Ghost of Carclew Street regards the house of Sergeant Ashburn of the Devon and Cornwall Militia. Next door to him lived Sergeant Major Candy, from the cavalry barracks, and this street never appeared to be the kind of place for supernatural disturbances. However, on 10 April 1821, unusual happenings started to occur, and Mrs Ashburn had noticed that her stockings had been removed from the garden washing line, while next door the neighbour noticed that his gooseberry bushes had been dug up and thrown around. Soon after this, things accelerated, and panes of glass were smashed by stones thrown in mid-air, appearing to be aimed at the Ashburns' house. The town resolved that the chaos must've been caused by a malevolent spirit.

The stone-throwing continued, and eventually Mayor John Ferris Benallack and two Kenwyn councillors, Clemence and Brown, arrived to see what all the fuss was about. Firstly, the windows of each house were to be barricaded, and the mayor asked the cavalry to keep watch. However, the stone-throwing continued, witnessed by hundreds of people; some said the stones were warm and smelled of brimstone. One woman declared that even though her windows were boarded up and the doors shut, plates and cups were still breaking.

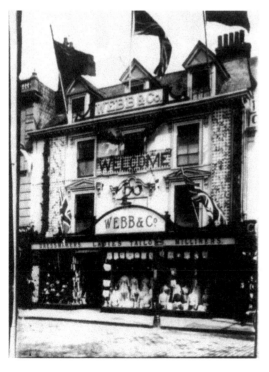

Webb's drapery shop in Boscawen Street.

Dr Lawrence Holker Potts, the old militia surgeon who treated Ashburn's head wounds in the Peninsular War, took the wife and treated her at his own house and then to, Trebilcocks Bake House, in Charles Street. After a few days of peace, the trouble started again, and Mrs Ashburn began to believe that the ghost had followed her. On returning to their own house, the strange happenings continued, but this time they weren't as violent.

Their older son, Tom, who suffered from fits and was caned in an attempt to cure him of his sick mind, was presumed to be responsible for the paranormal presence: he confessed that he'd wished ill of his mother for the beatings. A witch-hunt was started in the town and an old lady was nearly killed by a mob who tore at her clothes believing that she might harm people.

To this day, the true reason behind the stone-throwing remains unknown.

A Cat's Tale

People and buildings have stories to tell. This particular story alludes to that of a young lady who worked in the Littlewoods store on Boscawen Street several years ago. Previously Webb's Drapery Store, she had worked in the staff canteen at the top of the building, where the inexplicable wail of a cat could frequently be heard. Members of staff would diligently search the cupboards and furniture looking for the invisible feline, but it was never found. However, it was later revealed that the previous owner, Mr Webb, had a beloved cat that he kept in his office in the same part of the building. Seeing as both him and his cat had long passed away, the staff concluded that the sound must have come from the ghost of old Mr Webb's cat.

Truro Telephone Exchange, situated between Calenick Street and Kenwyn Street, the hub of most communications, has another tale to tell. The building, situated on the site of the thirteenth-century Dominican Friary, was greatly extended during the 1970s by British Telecom. Beside the door of the original entrance of the old building was a plaque carved with a monk's head set in the wall. Nearby, there was also an old hawthorn tree which was rumoured to hold an ancient curse: legend has it that the tree sat above the grave of an old monk who once lived at the monastery, and to cut it down would cause death to those within.

Those who worked at the phone exchange during the 1970s often overheard whispered stories that the ghost of a monk roamed the building. The night staff witnessed doors banging, and the fire doors in the main switch rooms were reported to have opened and closed on their own. Sadly, the tree was cut down by British Telecom, and in 1985 the *West Briton* reported that the staff were living in fear of the results of this ancient curse.

Millie Pascoe was a well-known Truronian character – an elderly lady who lost her fiancé during the war. She was often spotted around the town, especially in Gateway supermarket that used to be based in Victoria Square. Millie regularly shopped there, and often frustrated the girls on the tills as she insisted on reading out the dates of each of the coins she was about to hand over.

One day, while fulfilling his pocket money job in the supermarket, David Parnell can recall carefully weighing out 2 ounces of cheese for her while working on the deli. Another time after this incident, after being away on holiday, he decided to walk up to Malabar to see his mate and saw Millie sitting on the bench in Highertown. She greeted him by name, as she knew all the names of the Gateway staff, and David replied. On arriving at

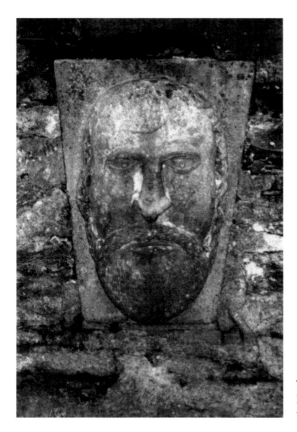

The face of a monk in the wall of the British Telecom building, connected to the old curse.

his friend's house, he said that he'd seen Millie and that they had spoken to each other, but he thought it was strange that she wasn't wearing her glasses.

On hearing this, David's friend was shocked. He told David that Millie had died a couple of weeks before.

More strange events took place at the jewellers, W. A. Vage. A respected establishment, it functioned in Truro from 1902 until 2006. Paul Vage worked in the shop for forty-one years with his son, who confirms the family's belief that they weren't alone in the shop. Paul frequently heard a knocking noise and doors would often slam shut, lodging themselves closed and unable to be opened. One day, to everyone's disbelief, the image of a lady appeared on the downstairs monitor of their security system. They'd learned that, historically, an old schoolteacher had been burnt to death in the same area, and they wondered if it was her.

Another Truronian mystery features in some hidden gravestones. Some years ago, the authors of the account went to view a property for a relative who wanted to move back to the city. After looking through the rooms and garden, they were ready to leave when they spotted a shed-like, black external door and a small, barred window in the wall. The estate agent was reluctant to let them take a closer look, but after several attempts they managed to open the door. Dark and sooty, they peered in and, looking to the right, were surprised to see a drop of several feet and, propped up against a far wall, two gravestones. The mound of earth looked freshly turned, and next to it lay a Cornish long-handled

A peaceful scene overlooking the Waterfall Gardens, where old gravestones form the wall.

shovel. It quickly became obvious that within this dark and sinister hole someone had been busy, although both were nonplussed as to what it could've meant. With no access to a torch or camera, it wasn't possible to capture, but the lasting impression was of an old carving on the stones, believed to be from around the late 1700s to the early 1800s. With the estate agent anxious for them to leave, they went away with many unanswered questions.

Research has revealed that there was never any consecrated ground in the area, and all sorts of theories have surfaced as to why these two gravestones should be there.

DID YOU KNOW THAT?

For many years, there's been a cross carved into a wall at Waterfall Gardens, and it's remained a mystery to many people. Recently, information has revealed that the wall is built from old, broken gravestones retrieved from St Clement's. Why this was done is unknown, but it has been noted that the inscriptions on the stones are turned away from the visible part of the wall and can't be read. This explains the presence of the cross.

Since the advent of Treliske Hospital, many people have referred to the Royal Cornwall Infirmary as the City Hospital as a means of differentiating between the two. The infirmary has given rise to many stories of strange events, especially the top floor, despite being renovated and turned into new apartments. Not long ago, a psychic was taken into an empty flat that was awaiting new owners, and she immediately sensed a form of energy in the hallway, feeling that something spent a lot of time travelling back and forth along a part of the corridor looking for light. The previous owner had kept orchids and complained that they kept being moved from one place to another, while a neighbouring apartment had frequently experienced lights being switched on and off for no apparent reason. Could this have been the ghost, looking for the light?

A Mr Lee Snook writes:

In the early 1980s, I had just returned home to work in the [then two] Truro hospitals, having completed my training at St Thomas' Hospital in London, but spent most of my time working at City. I worked across all four theatres, two of which, ENT and Ophthalmic, were on the top floor of the old infirmary building. The entrance to the children's ward was almost directly opposite the entrance to the ENT theatre. Many of the operations undertaken there were on children, so this made sense. The corridor ended nearby with the external end wall of the infirmary. One evening, probably about nine o'clock, I was just finishing tidying up after a late shift and went out into the main corridor. In my peripheral vision, I saw a girl aged maybe eleven or twelve standing at the end of the corridor. I was aware that this child was somehow 'out of time' with her surroundings. I couldn't swear exactly what she was wearing, other than that her clothes seemed old fashioned. As I mentally processed this, I was struck by the thought that although it wasn't unusual to see a child near the children's ward, it was late in the evening, and she should have been either in bed or preparing for surgery. As I turned to engage with her, she disappeared, both visually and apparently physically. As the corridor ended with the wall, there was nowhere for her to go. I thought for a long time that I had imagined or misunderstood what I had seen of this girl, except that I know her clothing was wrong for the 1980s, and at that time of evening she should have been in a gown, not a day dress.

Mr Snook continues:

This is something that both my wife (a radiographer at City) and I saw in 2014 in the old infirmary building, long after it was de-commissioned as a hospital and whilst it was being refurbished as dwellings. We lived opposite where the ward blocks used to be.

From about 2009 to 2015, the infirmary was covered with scaffolding, whilst the developer stripped the interior of stud walls, stairwells, floors and ceilings. Almost all that was left were the supporting walls, but little in the way of walkways, especially from the basement to the attic, some five floors in height. There was night-time security who would patrol the site out of hours to prevent theft of materials etc., so when we saw a moving light on the third floor one evening, we assumed it was a security patrol doing the rounds, except there was no third floor, just a void, and the light didn't appear

The Royal Cornwall Infirmary was replaced by Treliske Hospital. This fine old building has since been converted into modern apartments.

to be coming from a torch. This would have been bright and constant, only varying with its sweep. This light was yellow and flickering and was constant as it moved at walking pace from left to right, the sort of light that would be produced from a candle or a lantern. Perhaps someone was patrolling, but I don't think it was the duty security officer. I can't be definitive that these events were one thing or another; they might be interpreted in different, yet still coherent, ways. I had no witness to the first event, and although my wife witnessed the second, I couldn't confirm the following day that it was, or wasn't, security related. Both have stuck in my mind as the more unusual events, but most people who have worked in the infirmary have similar stories of things, not seen or unexplained.

Behind the façade of the smart shopfront of Hotter Shoes in Pydar Street lies another ghostly tale. When workmen were renovating the building, they encountered some chilling experiences of apparitions in a room at the top of the building. The original ceiling beams and fireplace of the old building remain the same, and a shadowy image has been seen in both.

A mysterious locked room at the rear of Hotter Shoes.

A woman is often seen at the window, which overlooks the rear car park. A man is reputed to have hanged himself in that room, which is presently only used for storage and usually kept locked. It's a secret of secrets.

A ghostly figure of a woman is reported to reside at Hendra Hair & Beauty in Lemon Street. It's believed that the spirit is that of a beautiful woman who once used it as her bedroom many years ago.

Viv Hendra addresses the story:

It has been funny here, because I hadn't told the family I thought it was haunted, and they hadn't told me the same thing! There is nothing spectacular in my story; I have only been in the building after dark on my own on one occasion, after the Truro City of Lights last year. I was washing up the coffee cups on the top floor and ready to lock up when there was a sudden feeling that somebody else was in the room. I left the building and locked up as quickly as I could.

Recently, Debbie, one of the presenters at the Radio Cornwall studio, gave an interesting and thrilling tour of the building. Debbie relayed uncanny tales and suspicious sightings from various members of staff.

Walking from a corridor into an older part of the building, a chilly atmosphere hit. Apparently, an apparition of a man wearing a leather-type jacket and fumbling with keys had often been seen here. In another room, used as a little kitchen, draws and cupboard doors were found wide open in the mornings, when they had been securely closed from the night before. A woman wearing a cape had been seen in the recording studio, and an uncanny apparition in the reception area. The presenter showing us around recalls that on one occasion someone wiped her brow while she was recording her programme, a spooky incident that quite unnerved her. The building that is home to Radio Cornwall overlooks the Truro River, which once was a very busy shipping area. No doubt there are many mysteries within its walls – but for now they remain a secret.

11. The Cross Restored

On a cold winter's morning in November, when the city was still dark, a few people were gathered at High Cross. Andrew Langdon, an expert on Cornish crosses, was there with the vice president and honorary secretary of Truro Old Cornwall Society. Stonemasons C. F. Piper & Son had come down from Bearah Tor Granite Quarry and were drilling a core out of what had been the base of the shattered shaft. When this was done, the hole was covered over in order to let it dry out – it had to dry out before the cross could be re-erected, which posed quite a challenge in the wintery weather.

A week later, they were all back at the scene. This time the stonemasons had the repaired cross with them, and with great skill, the cross was lowered into position with the assistance of a large crane.

The cross was back in place just in time for Christmas, where churchgoers leaving the cathedral after evening services were greeted not only by the sight of a large Christmas tree and lamp posts festooned with twinkling lights, but also, standing in the darkness, where it always belonged, the High Cross.

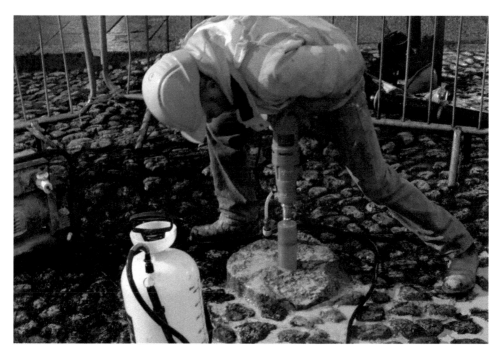

The base of the shattered shaft being drilled in preparation for the new stainless steel pin which would enable the re-erection of the old cross.

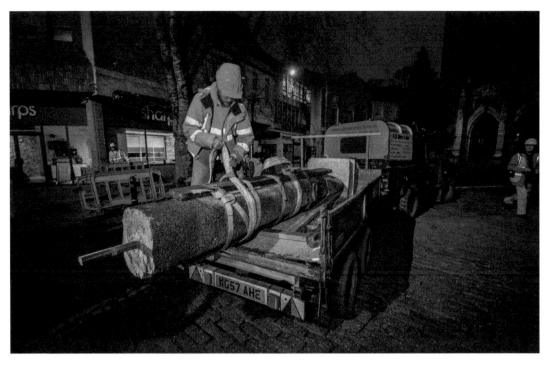

One of the stonemasons carefully untying the secured cross.

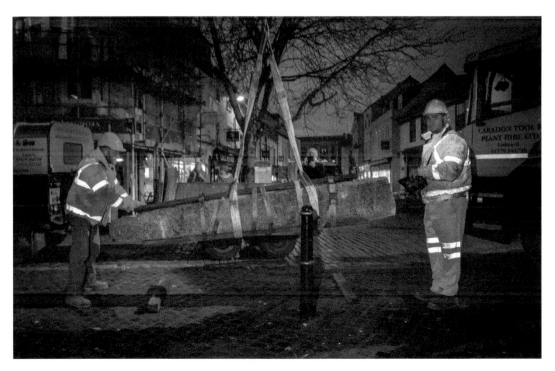

A tense moment in the early morning light, as the cross is lifted by the crane.

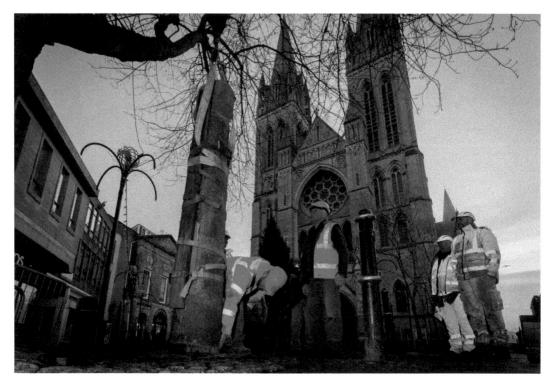

At last, the cross is eased into position.

Sunrise illuminates Truro, with the silhouette of the bridge visible in the foreground.

Bibliography

Barratt Rex, *Life in Edwardian Truro* (Rooster, 1977)

Barratt Rex, *Memories of a Truronian in War and Peace* (Dyllansow Truran, 1981)

Bagnall Polly and Beck *Sally Ferguson's Gang* (National Trust Books, 2015)

Bourne, F.W, *The King's Son* A Memoir of Billy Bray (Hamilton Adams & Co, 1887)

Rowe, Ashley, cuttings from the *West Briton* and *Argus*

Palmer, June, *From Moresk Road to Malpas* (Truro Buildings Research Group, 1988)

Palmer, June, *Pydar Street and the High Cross Area* (Truro Buildings Research Group, 1975)

Pollard, Margaret and Faith Godbeer, *The Guild of Our Lady of the Portal* (Dyllansow Truran, 1985)

Truro Buildings Research Group, *Princes Street and the Quay Area* (Truro Buildings Research Group, 1976)

Truro Buildings Research Group, *River Street and its Neighbourhood* (Truro Buildings Research Group, 1985)

Truro Buildings Research Group, *Lemon Street and its Neighbourhood* (Truro Buildings Research Group, undated)

Truro Buildings Research Group, *Boscawen Street Area* (Truro Civic Society and Truro Buildings Research Group, 1981)

Acknowledgements

Special thanks are due to Alan Richardson, who has been in the background ready to help in any way and also to Jonathan Jacobs, who has let us use his excellent photographs.

Bert Biscoe
Viv Hendra
Alison and Rob Hill
Lawrence Holmes
Margaret Hosegood
Christopher Jacobs
John Lean
Sandria Lewis
Tony Mansell
Paul Mitchell
Kathryn Oatey
Grenville Penhaligon
Jenna Richardson
Colin Scofield
Diana Smith
Lee and Helen Snook
Mac Waters

If we have overlooked anybody, please accept our apologies.